Charming
Coloring Book

Expreme Stress Remedy

by

Ronald K

All rights reserved. No part of this book may be reproduced in any form without written permission of the copy right owners.

This book is meant to supplement, not to replace medical advice.
There are no representations or warranties about the reliability or accountability with respect to the information or related graphics contained in this book for any purpose.
If you would like to see more images and stay updated on new coloring books,
visit our website at
www.doleyo.com

ISBN: 9781793958549

printed in the USA

Copy right ©2019 Doleyo

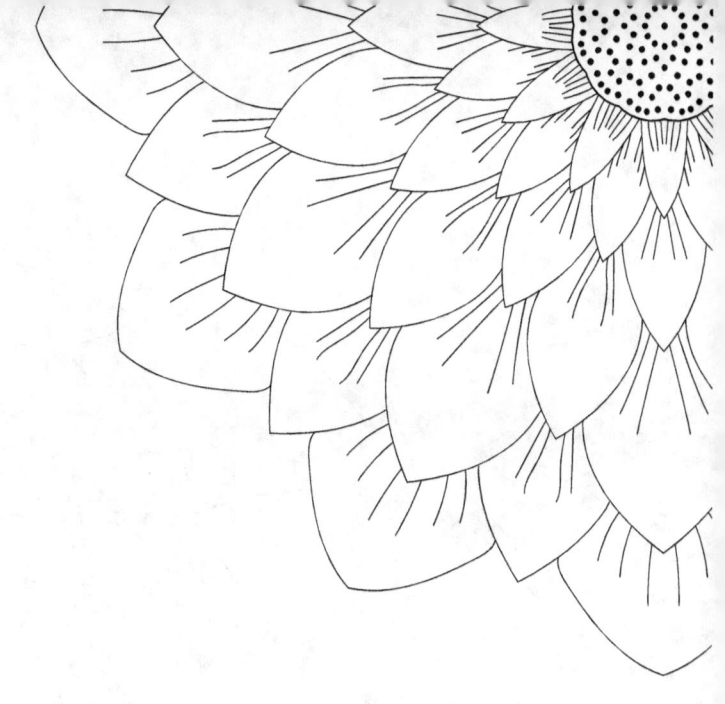

Painted With Love

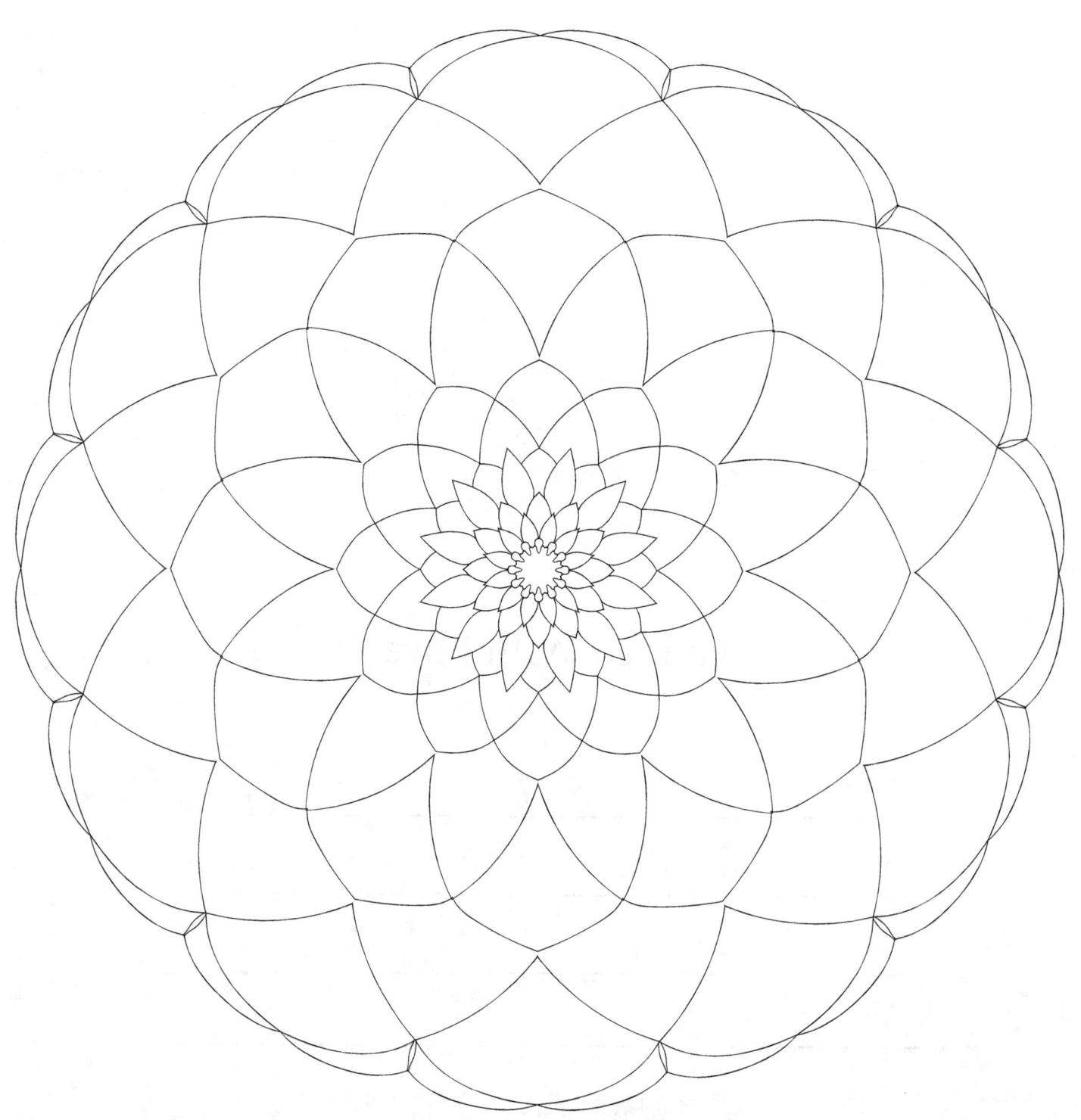

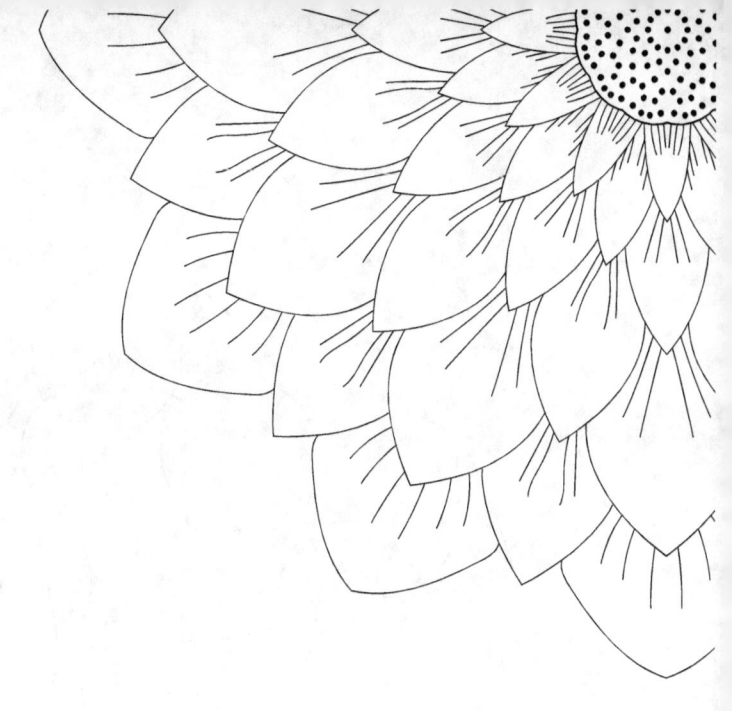

Painted With Love

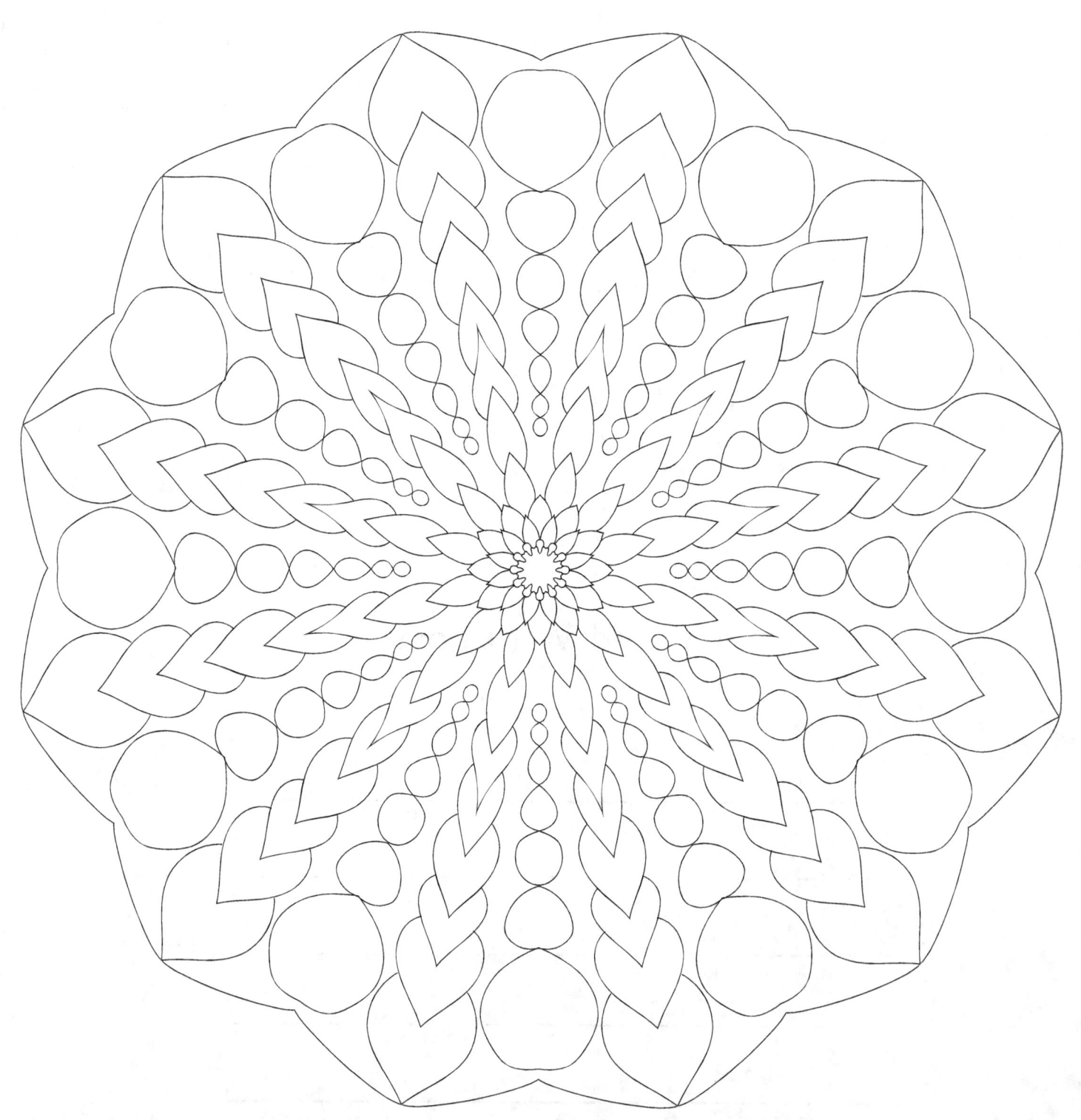

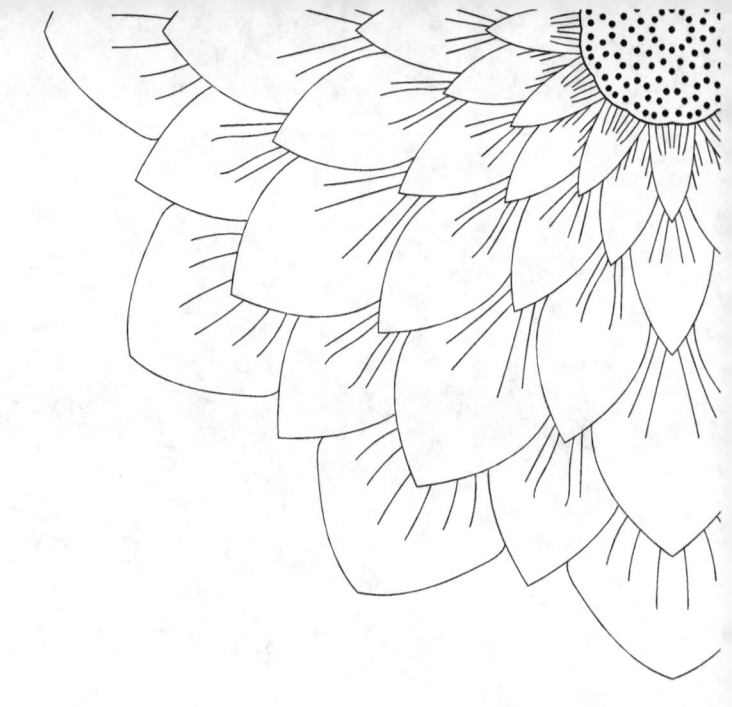

Painted With Love

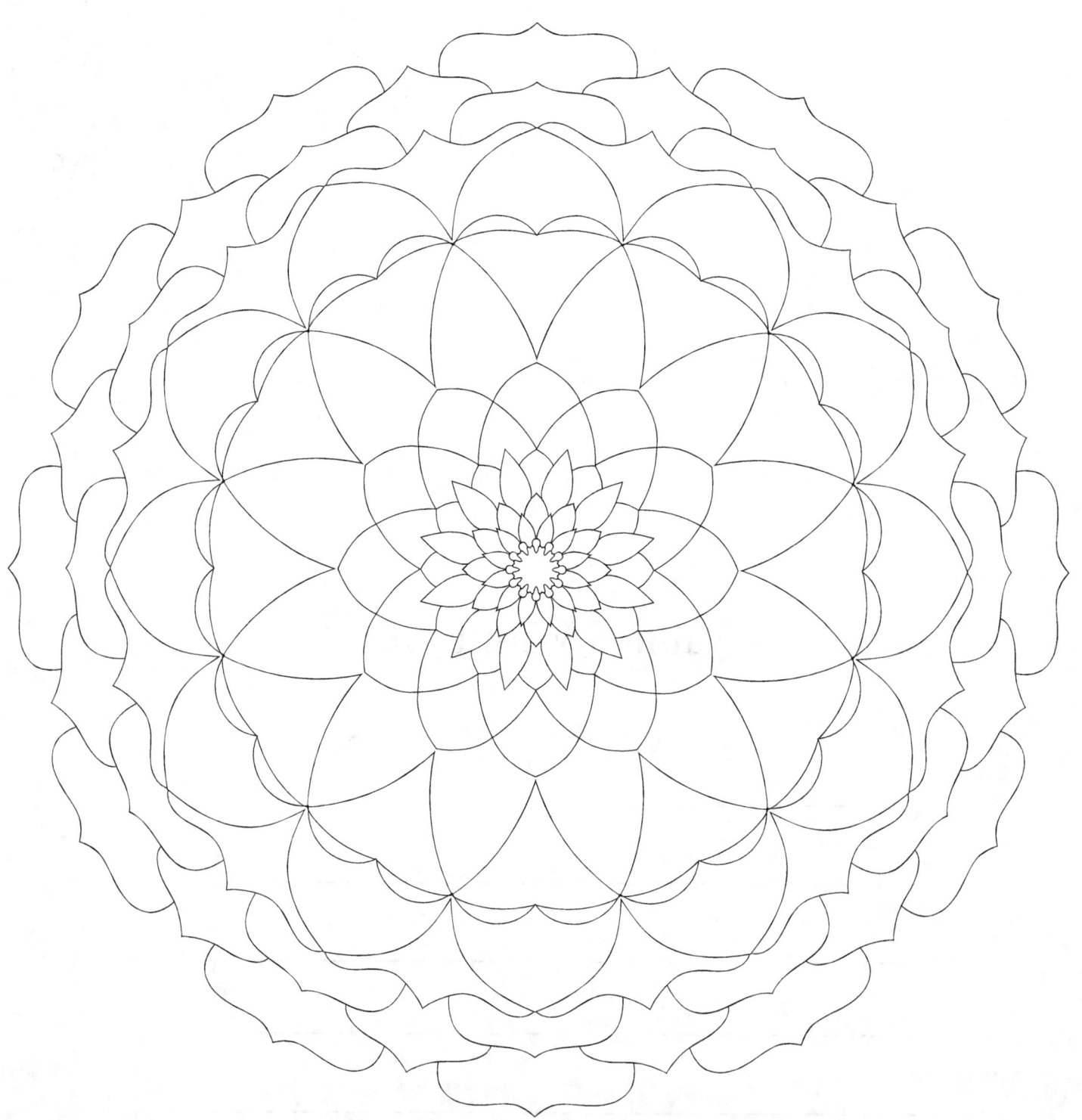

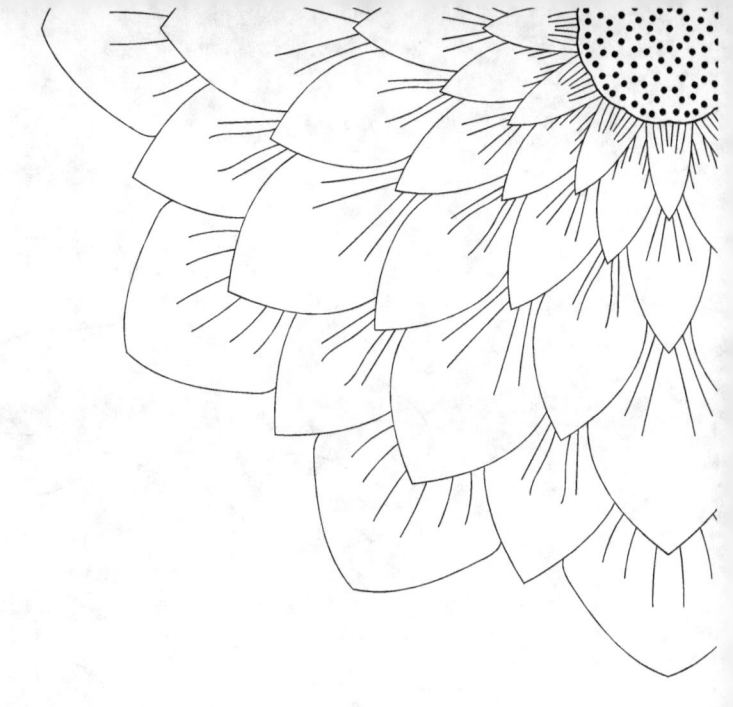

Painted With Love

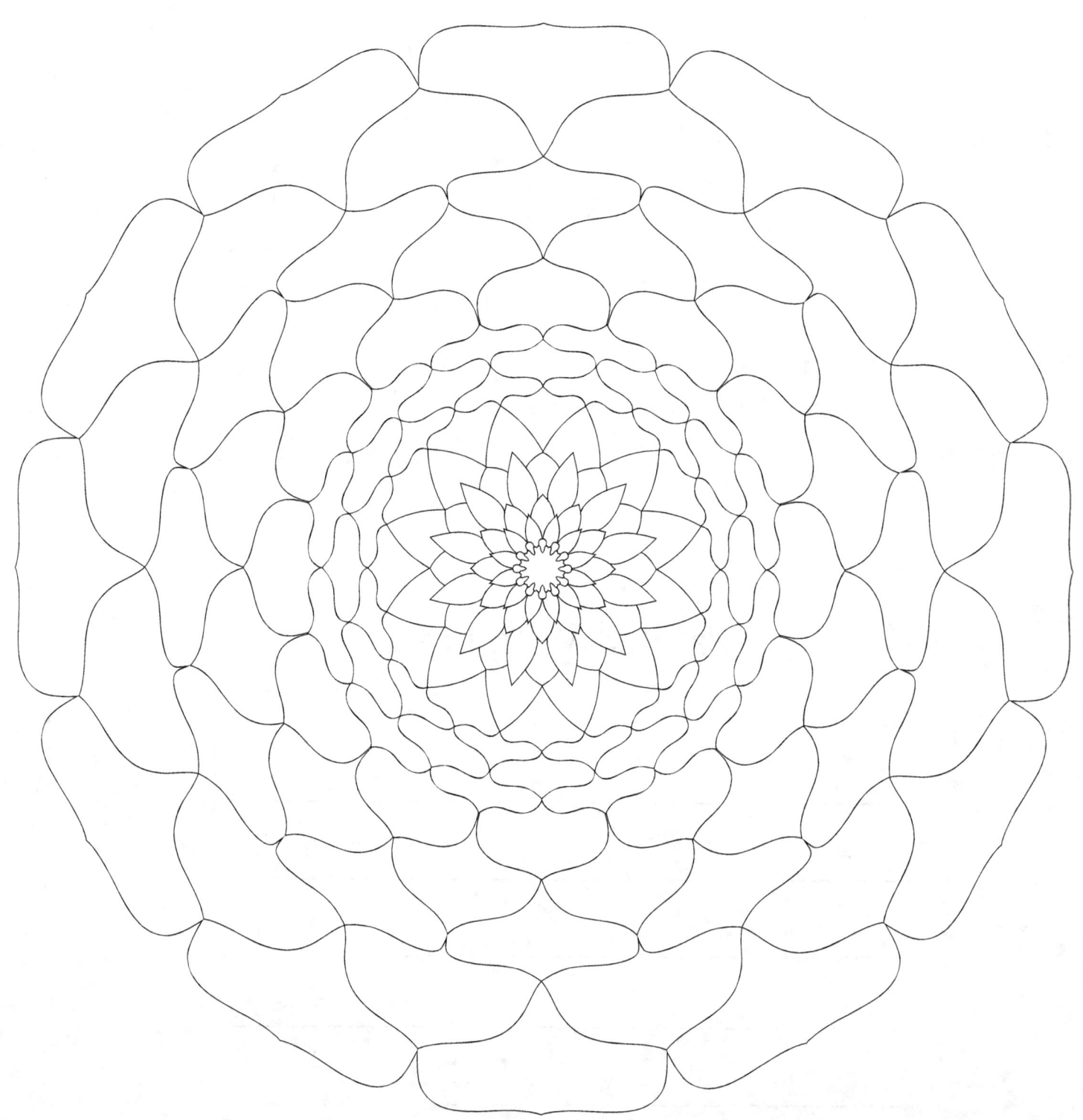

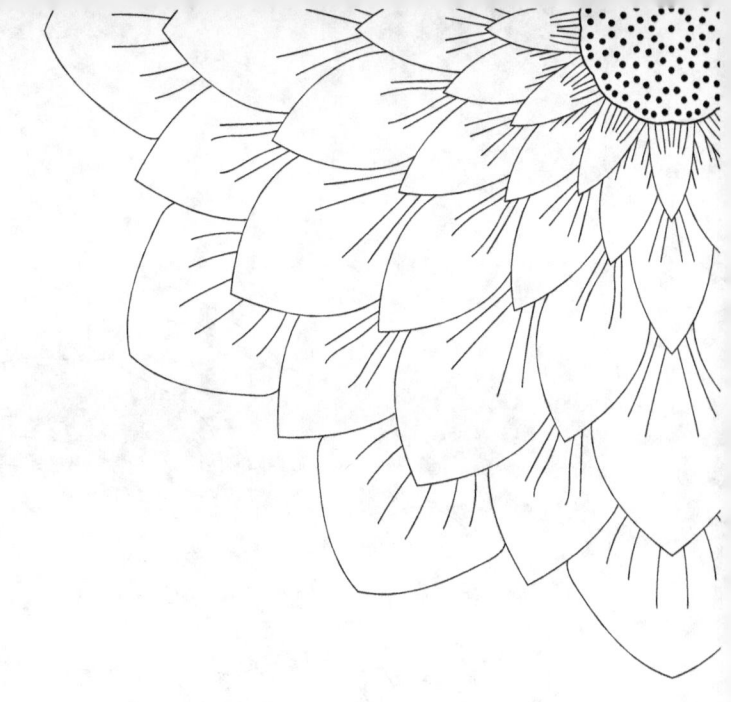

Painted With Love

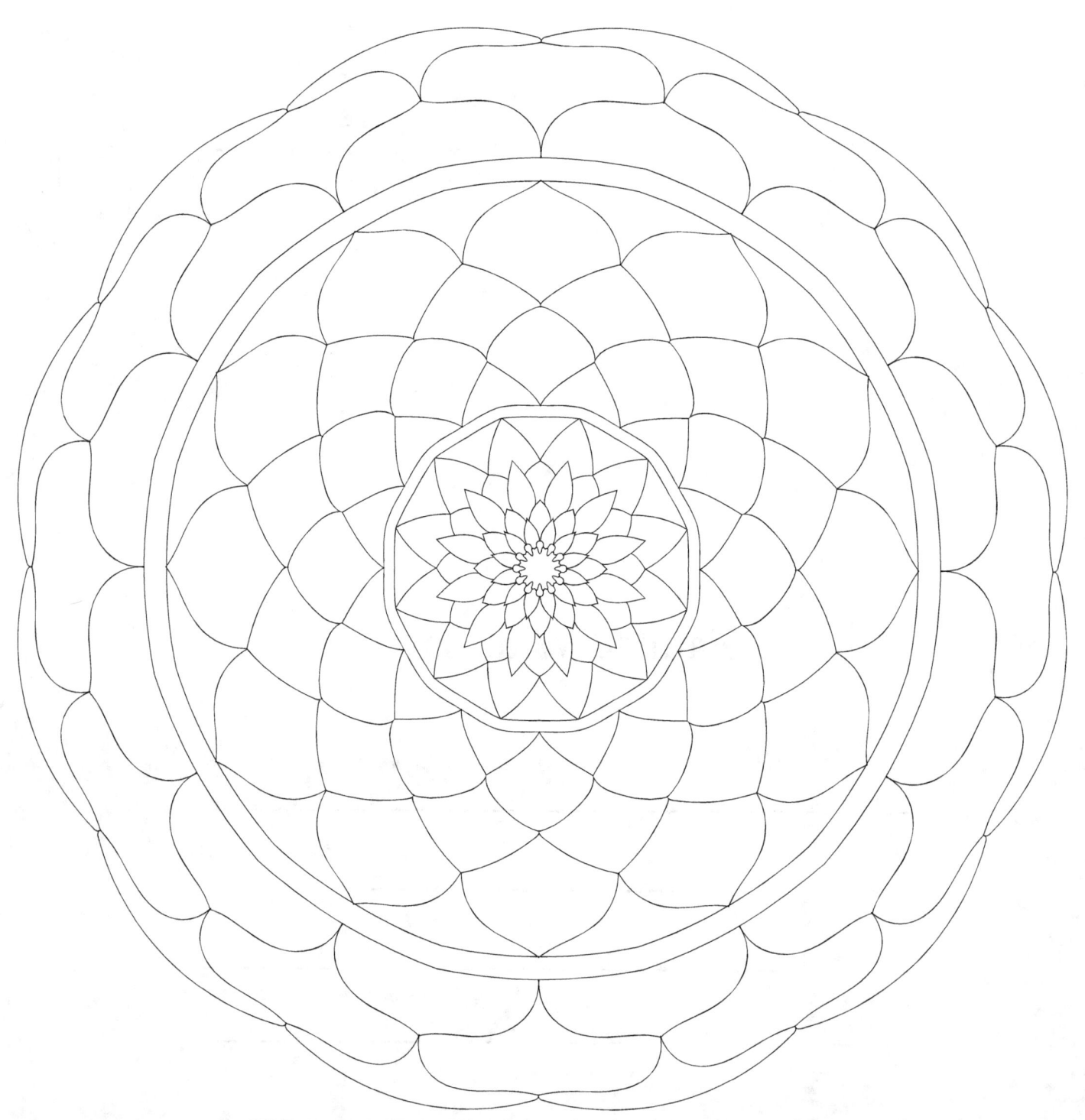

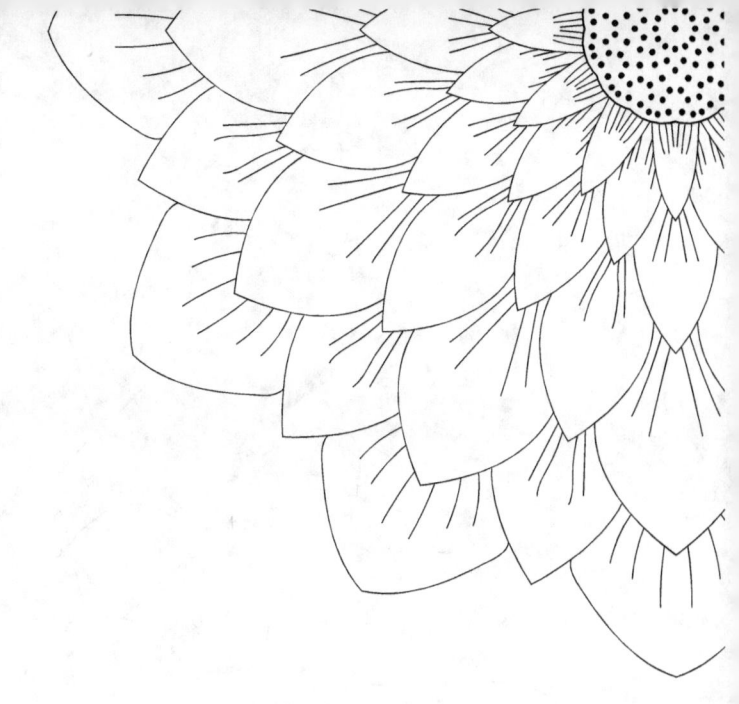

Painted With Love

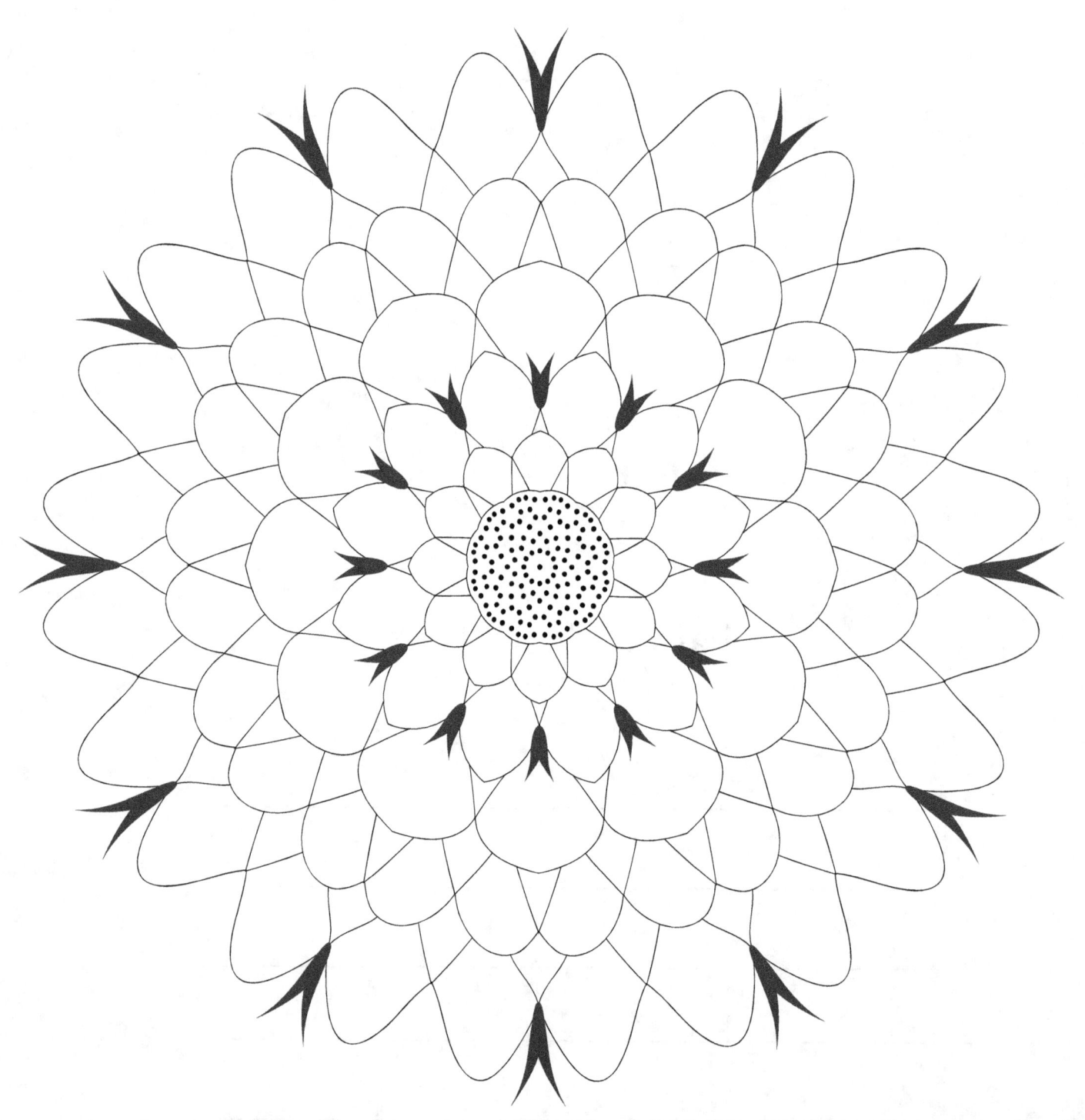

Painted With Love

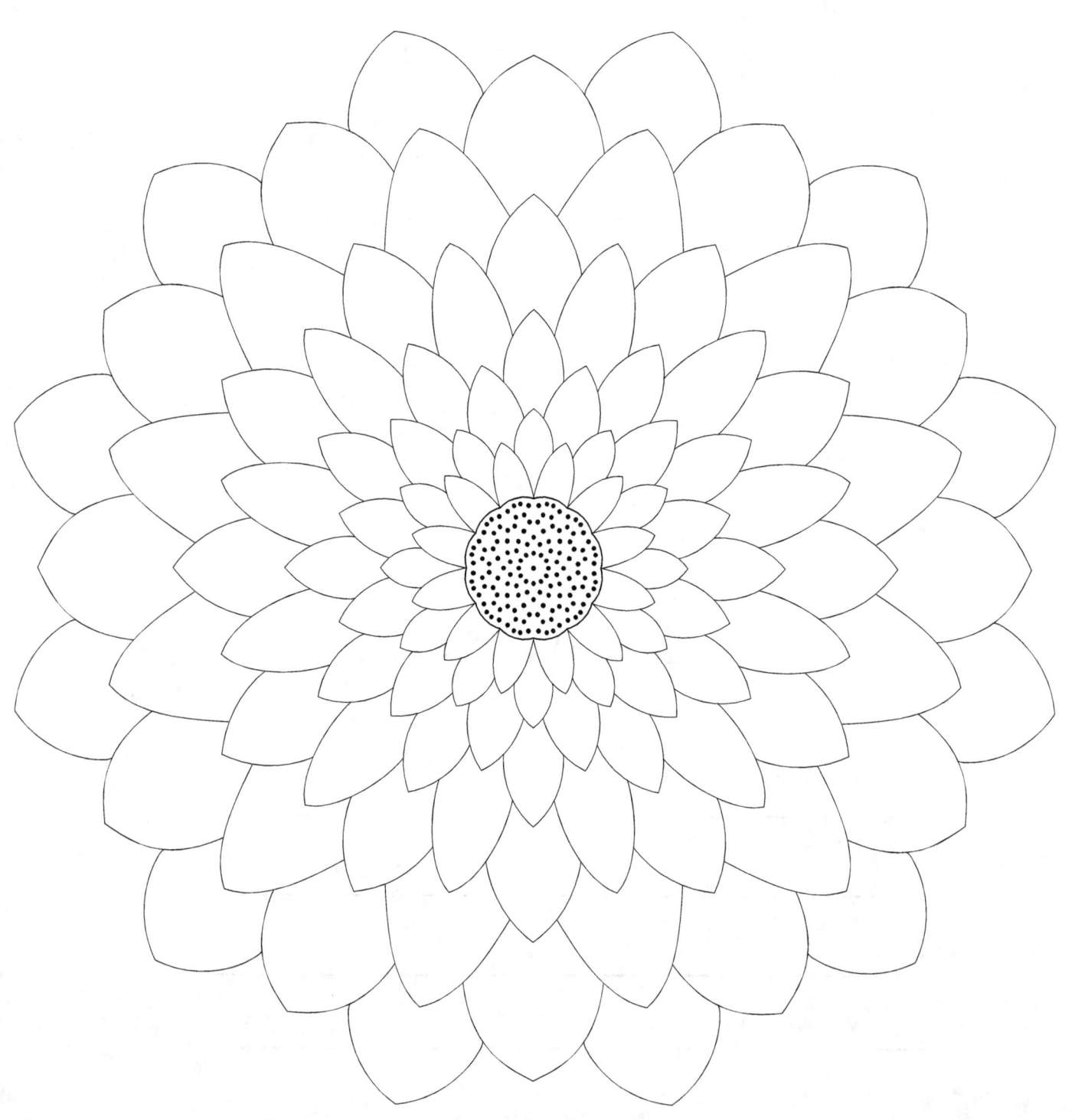

Painted With Love

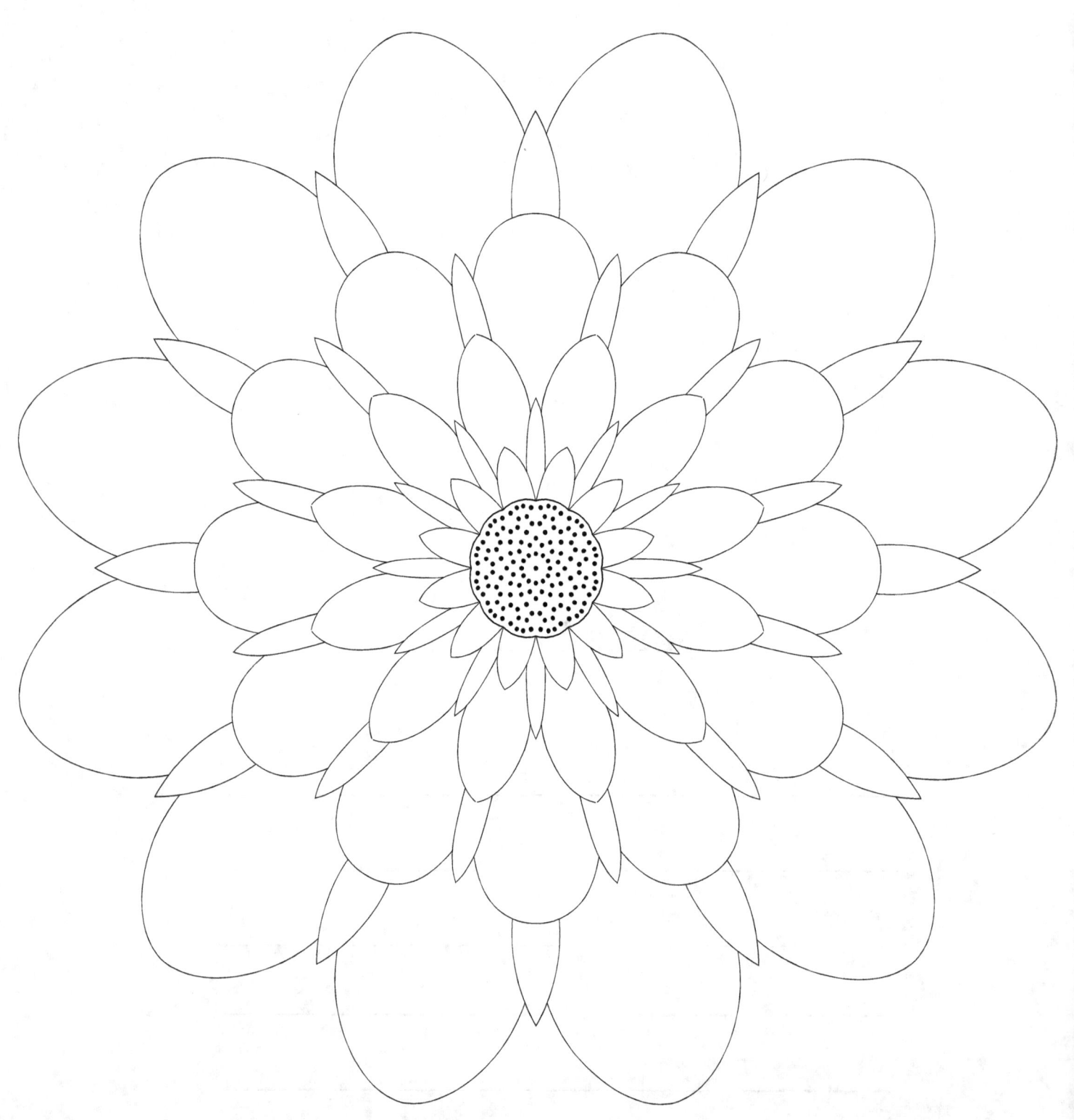

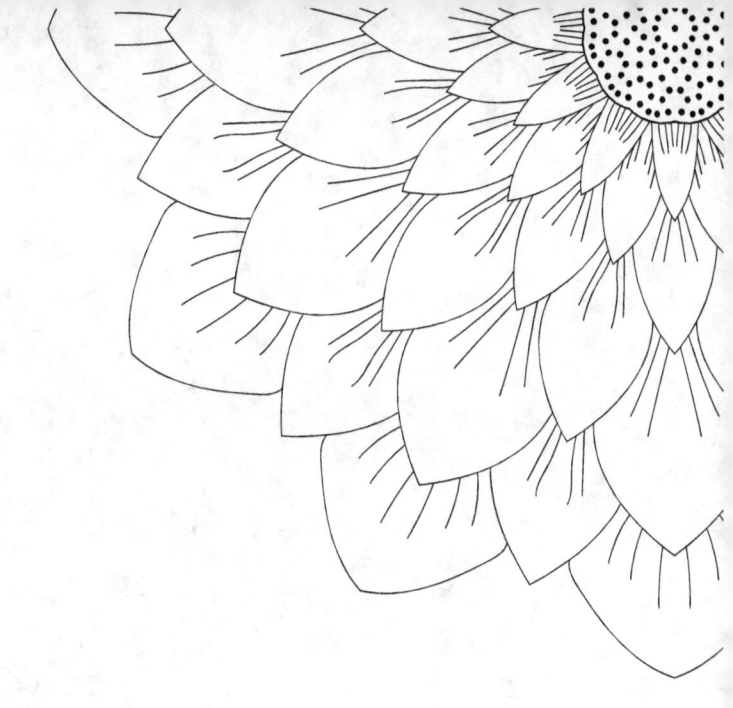

Painted With Love

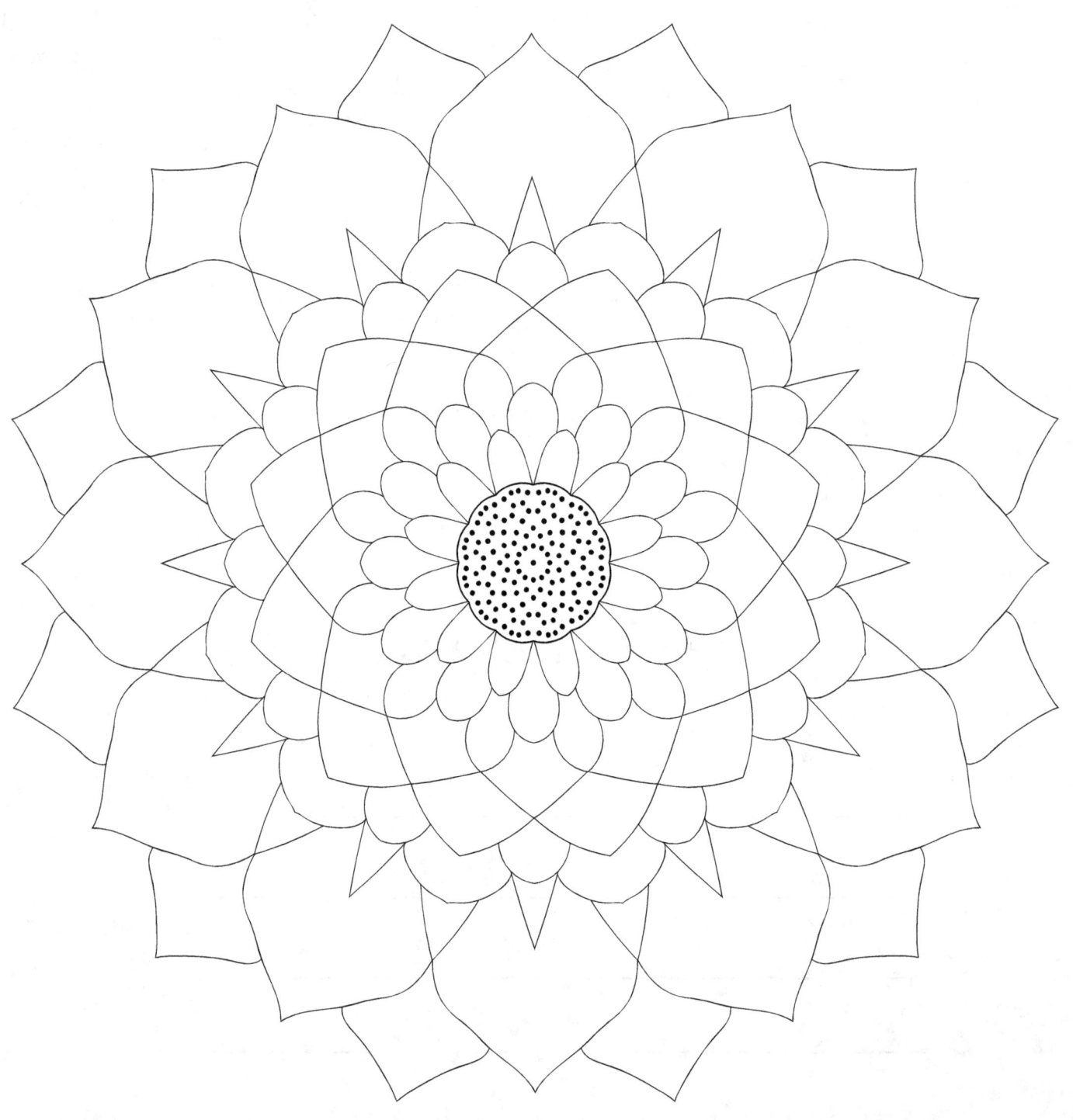

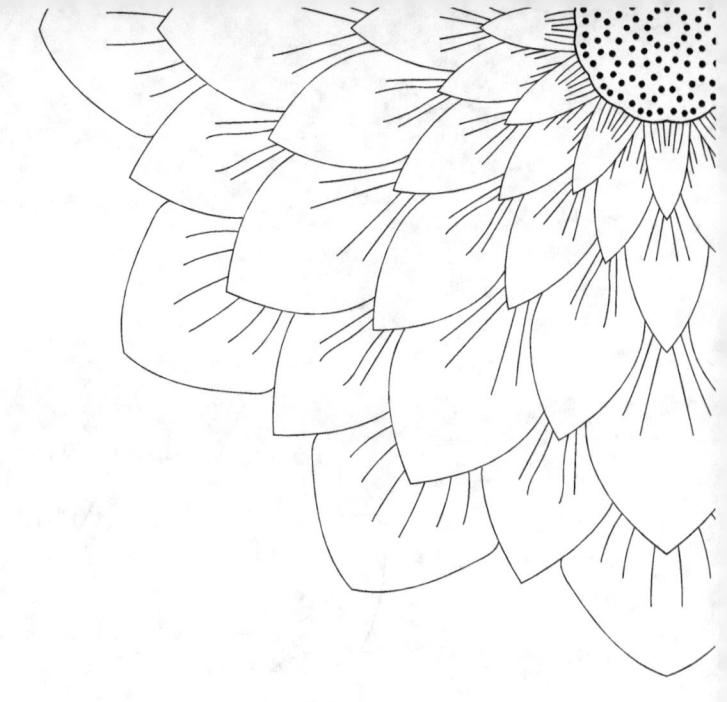

Painted With Love

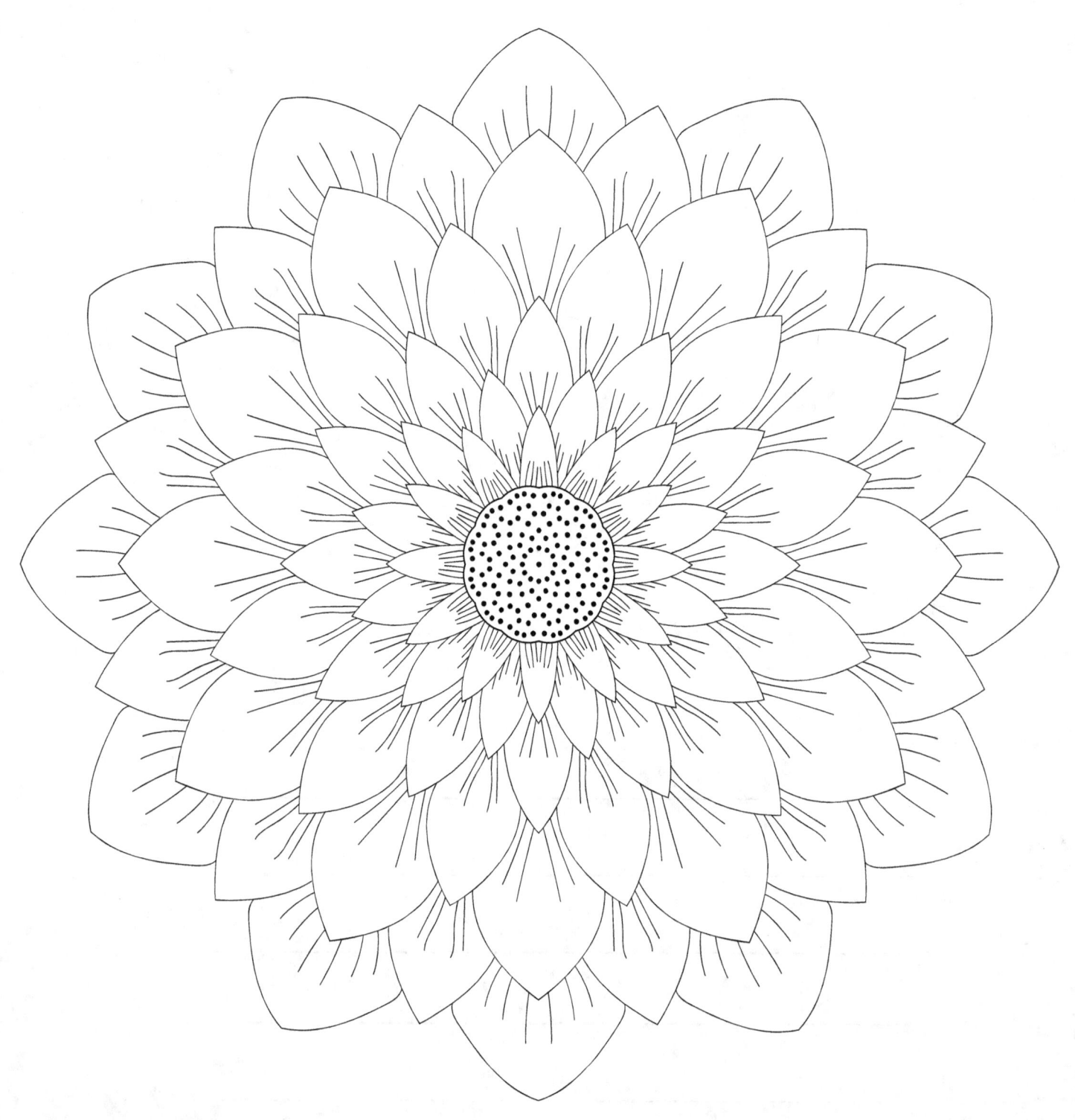

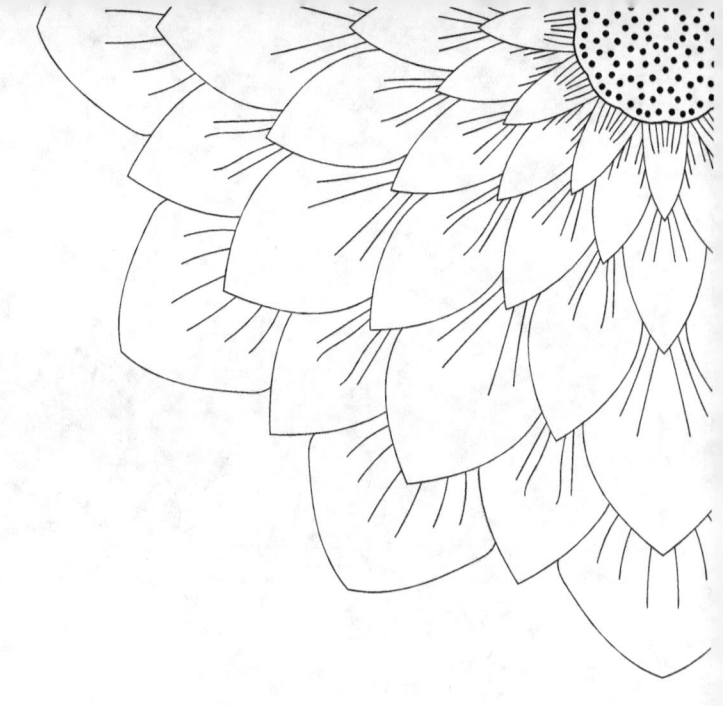

Painted With Love

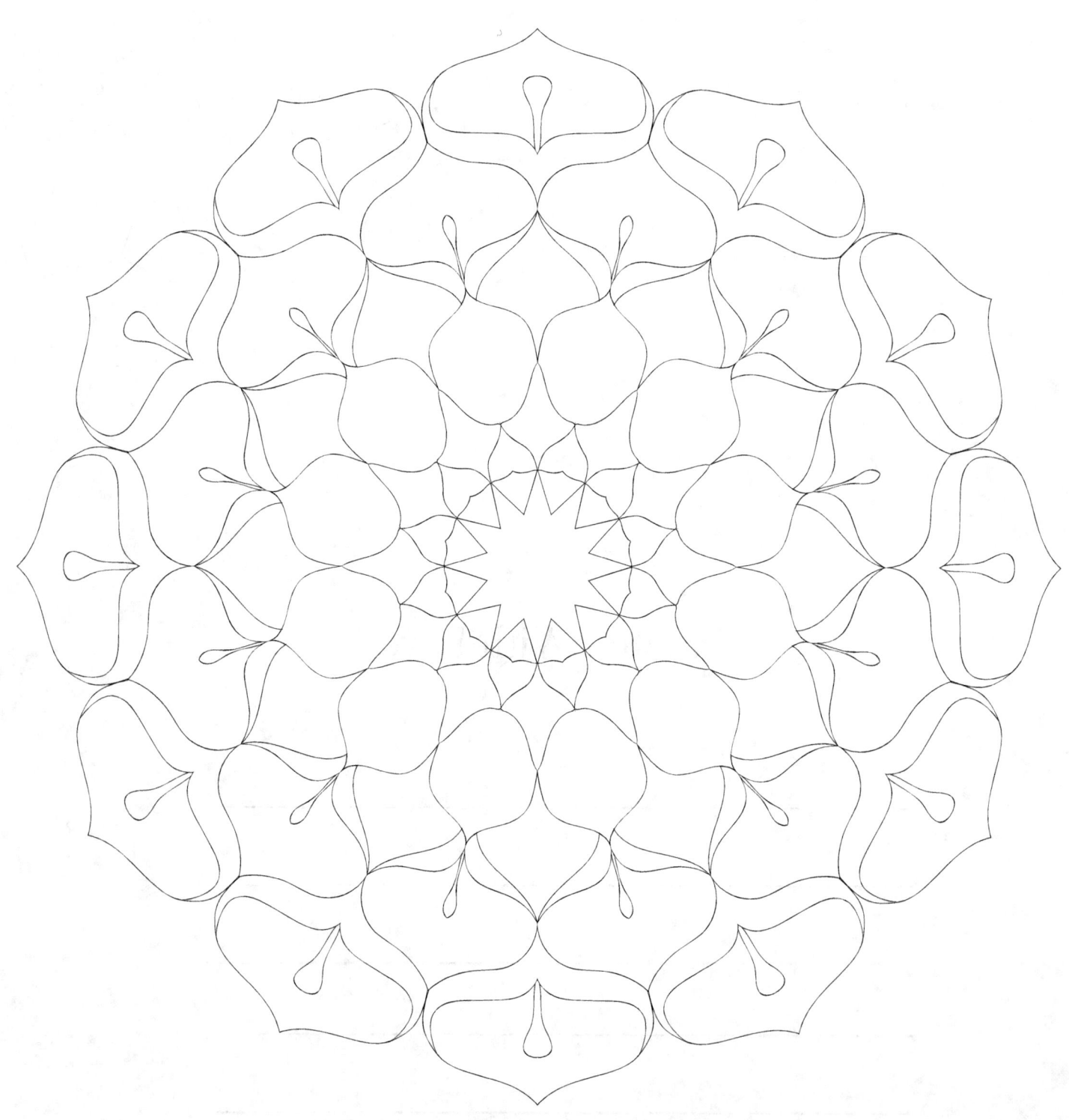

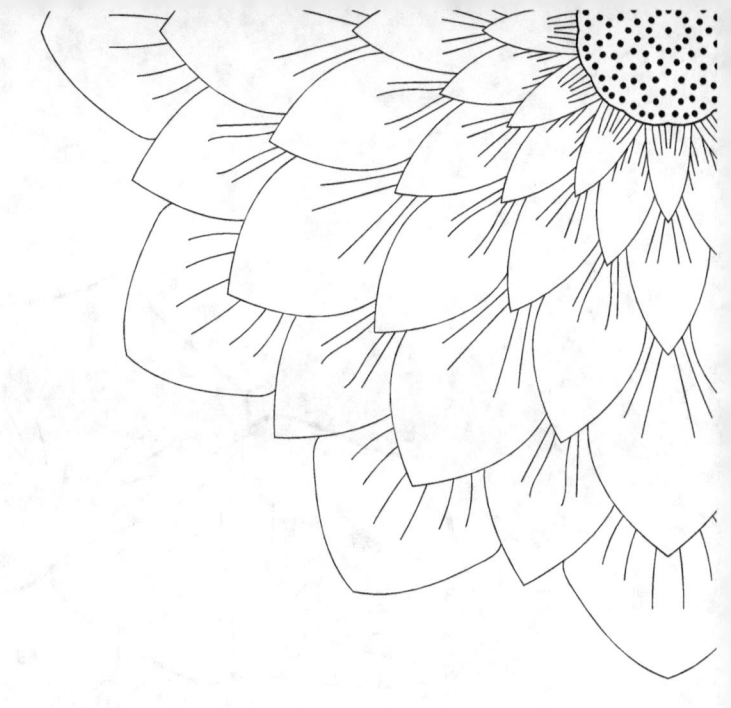

Painted With Love

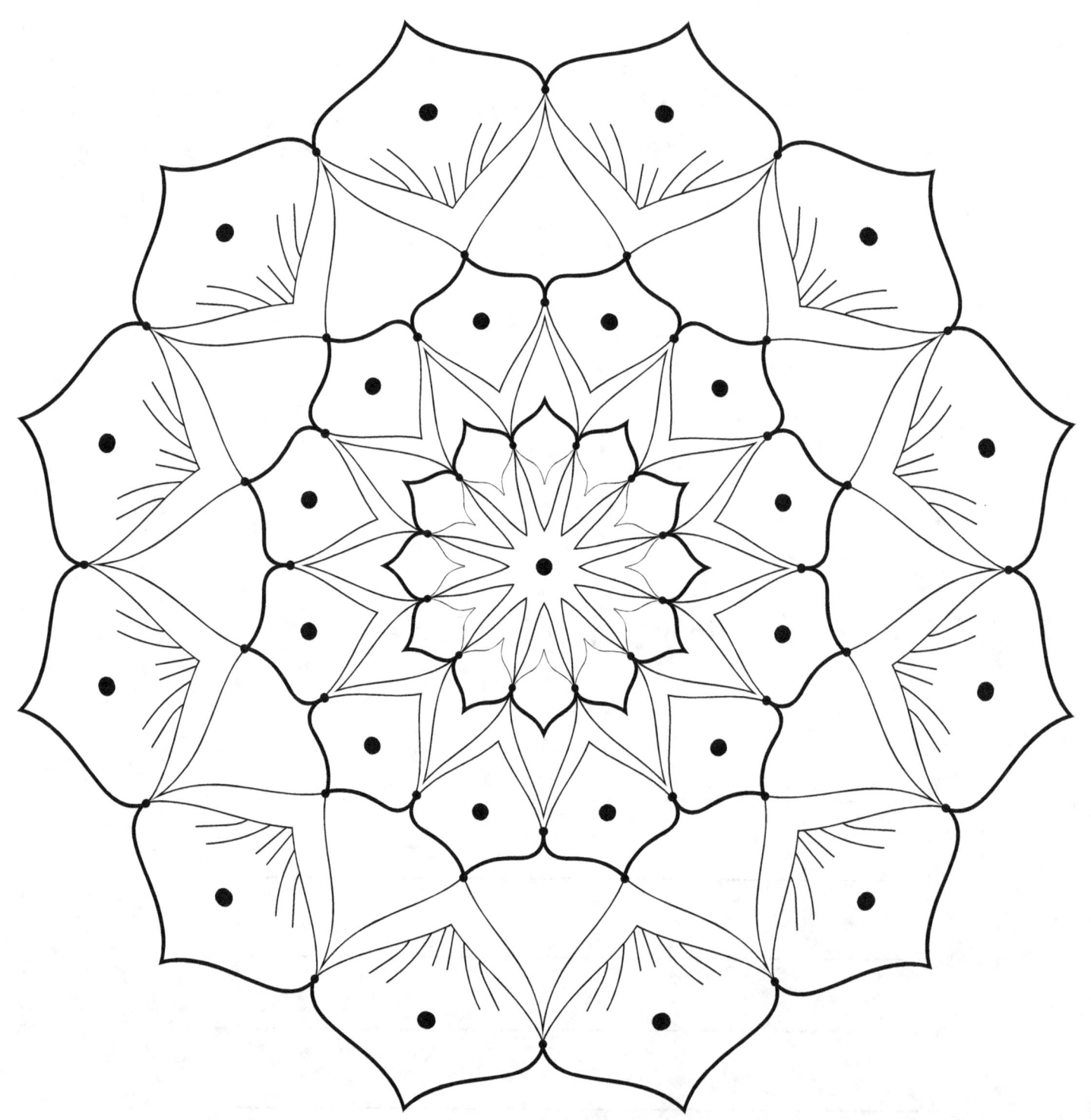

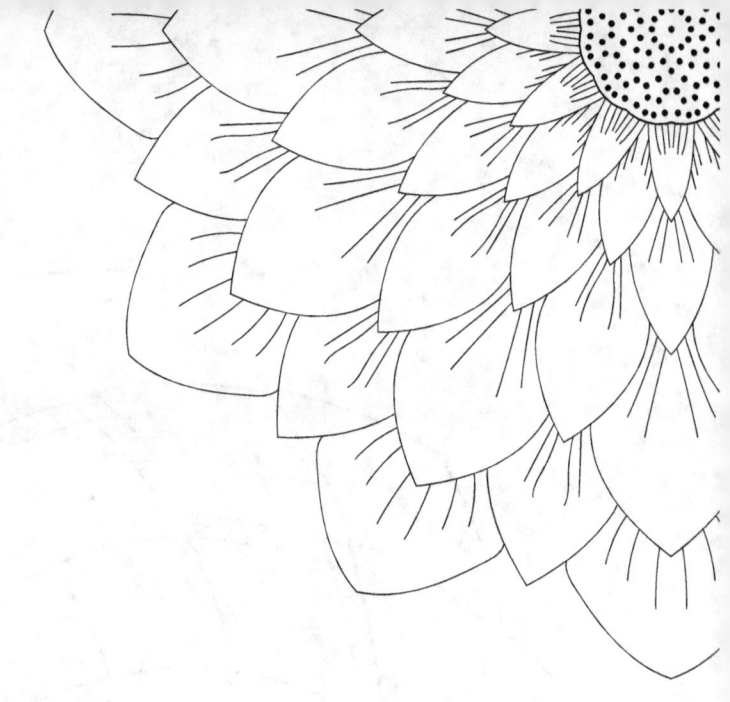

Painted With Love

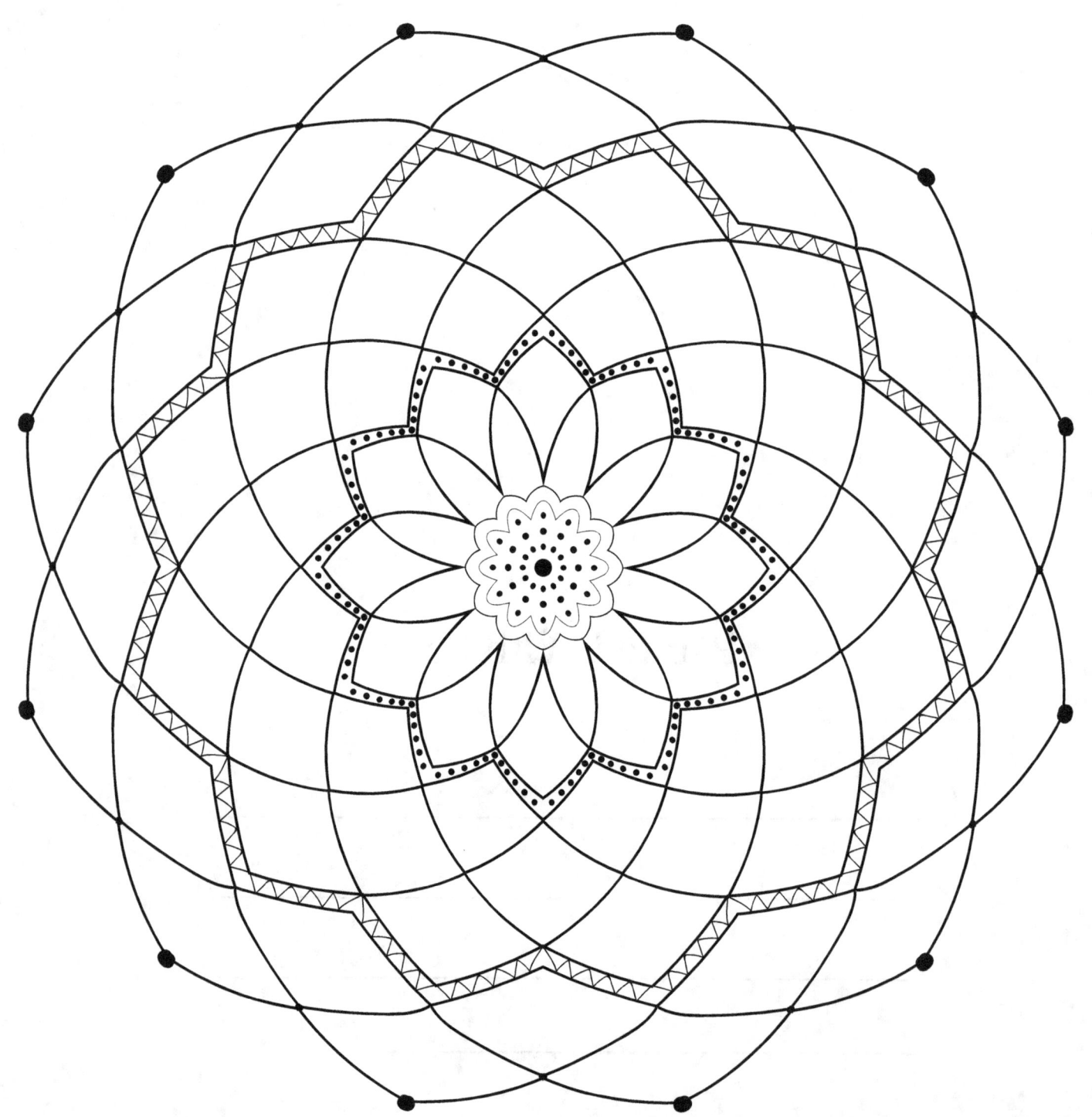

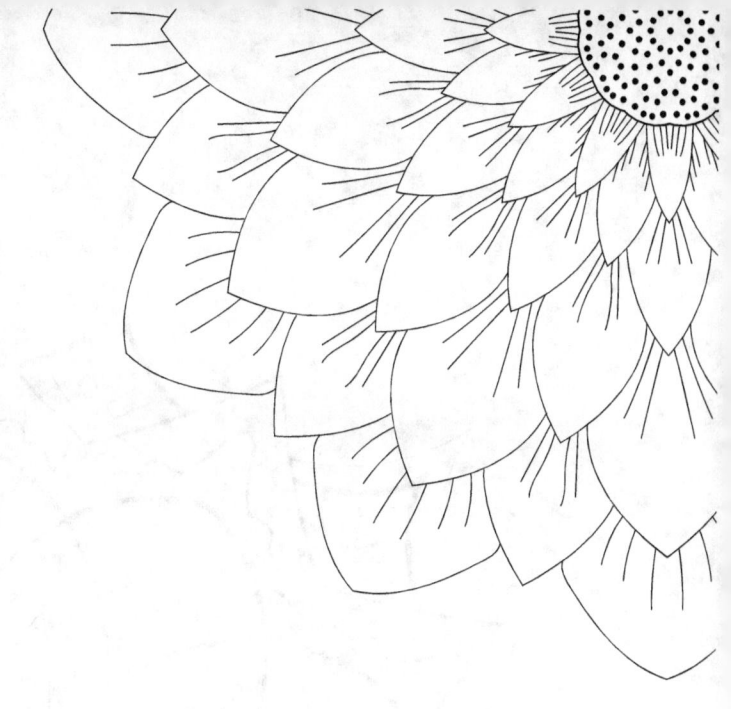

Painted With Love

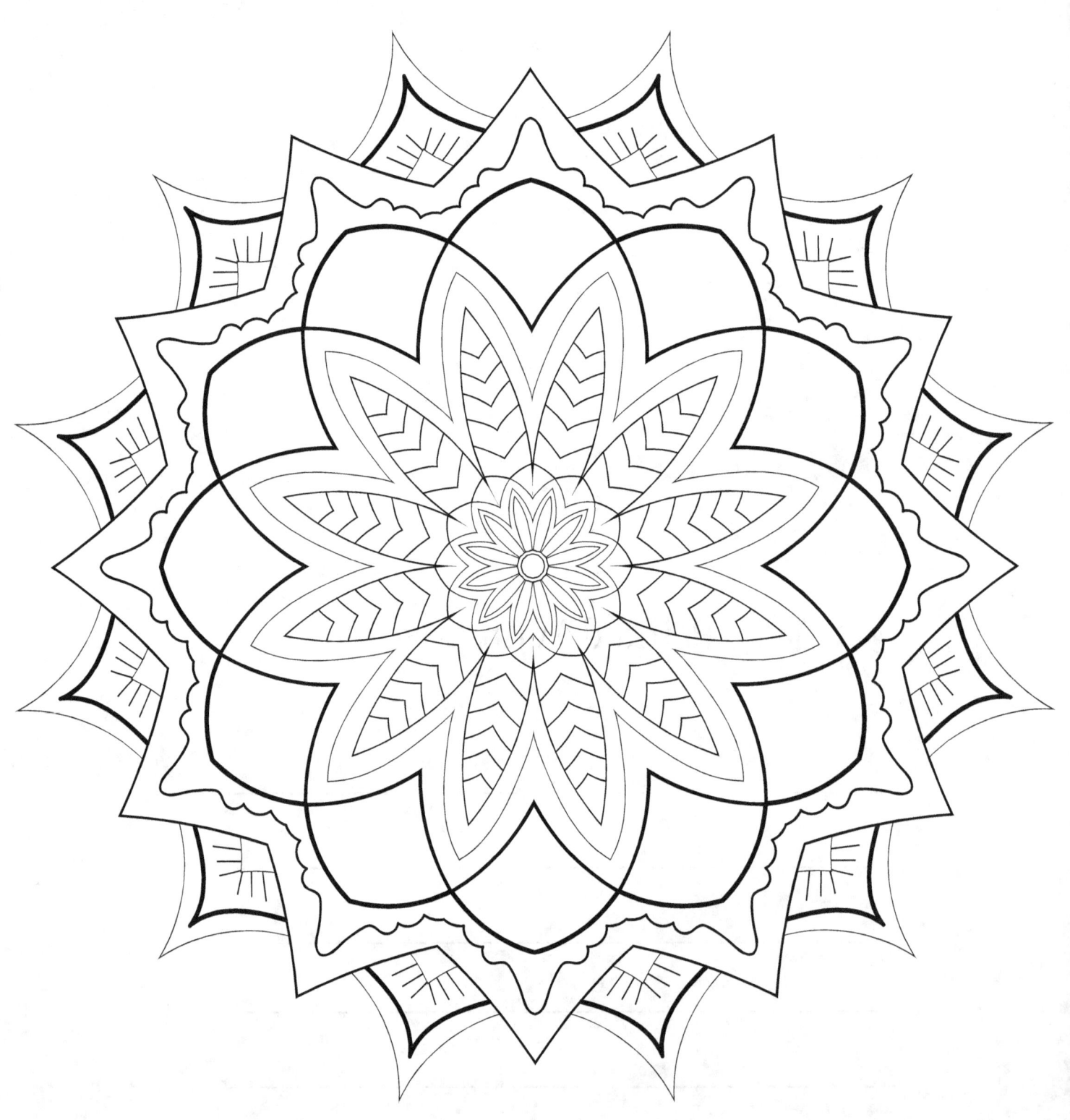

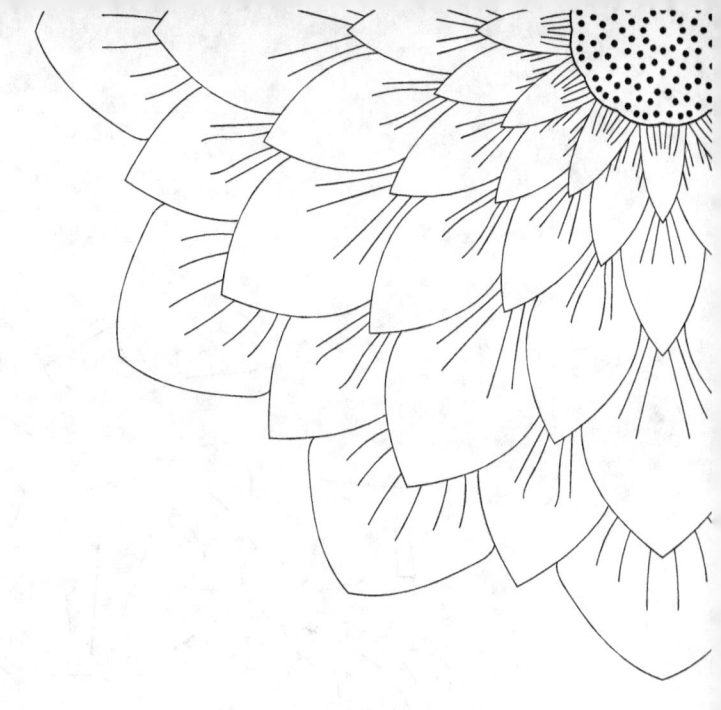

Painted With Love

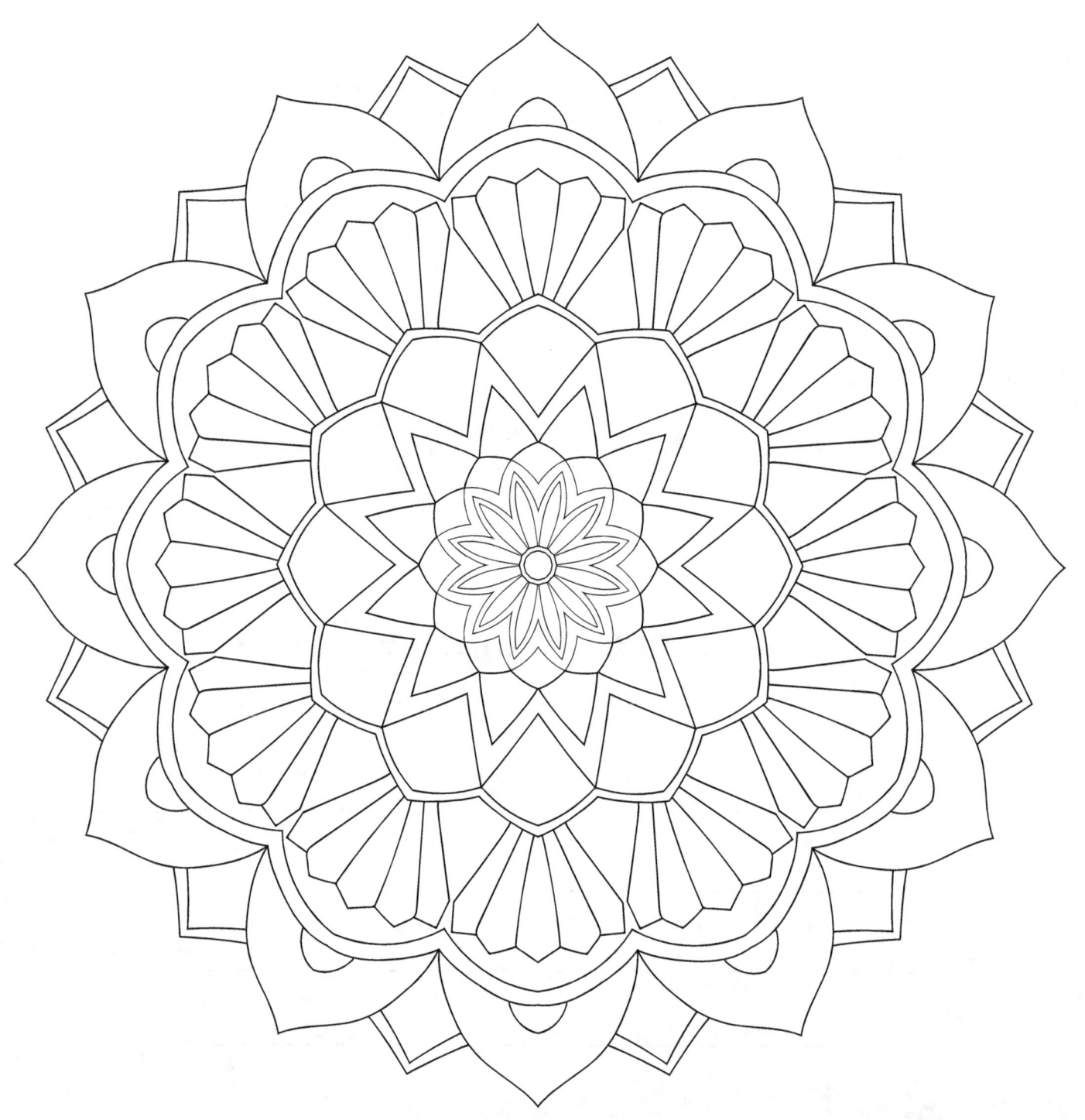

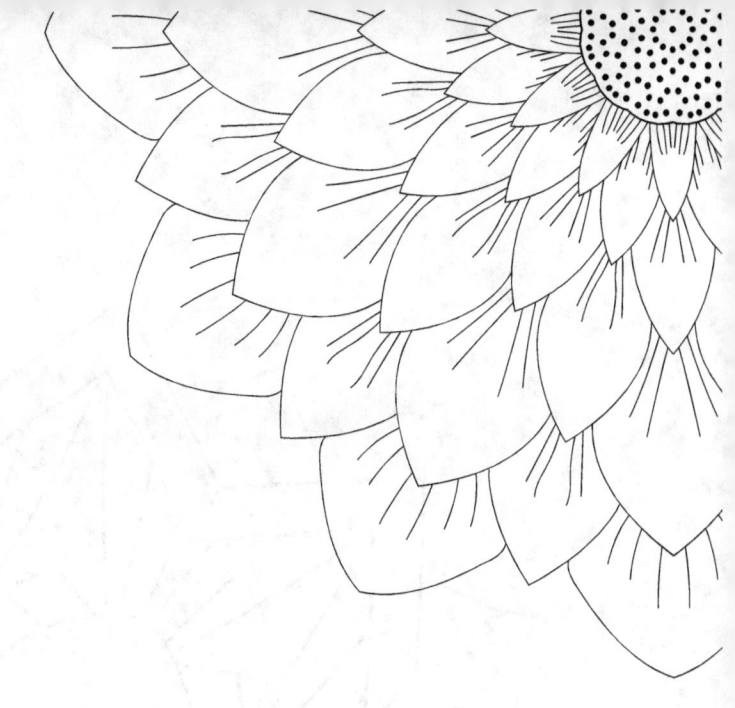

Painted With Love

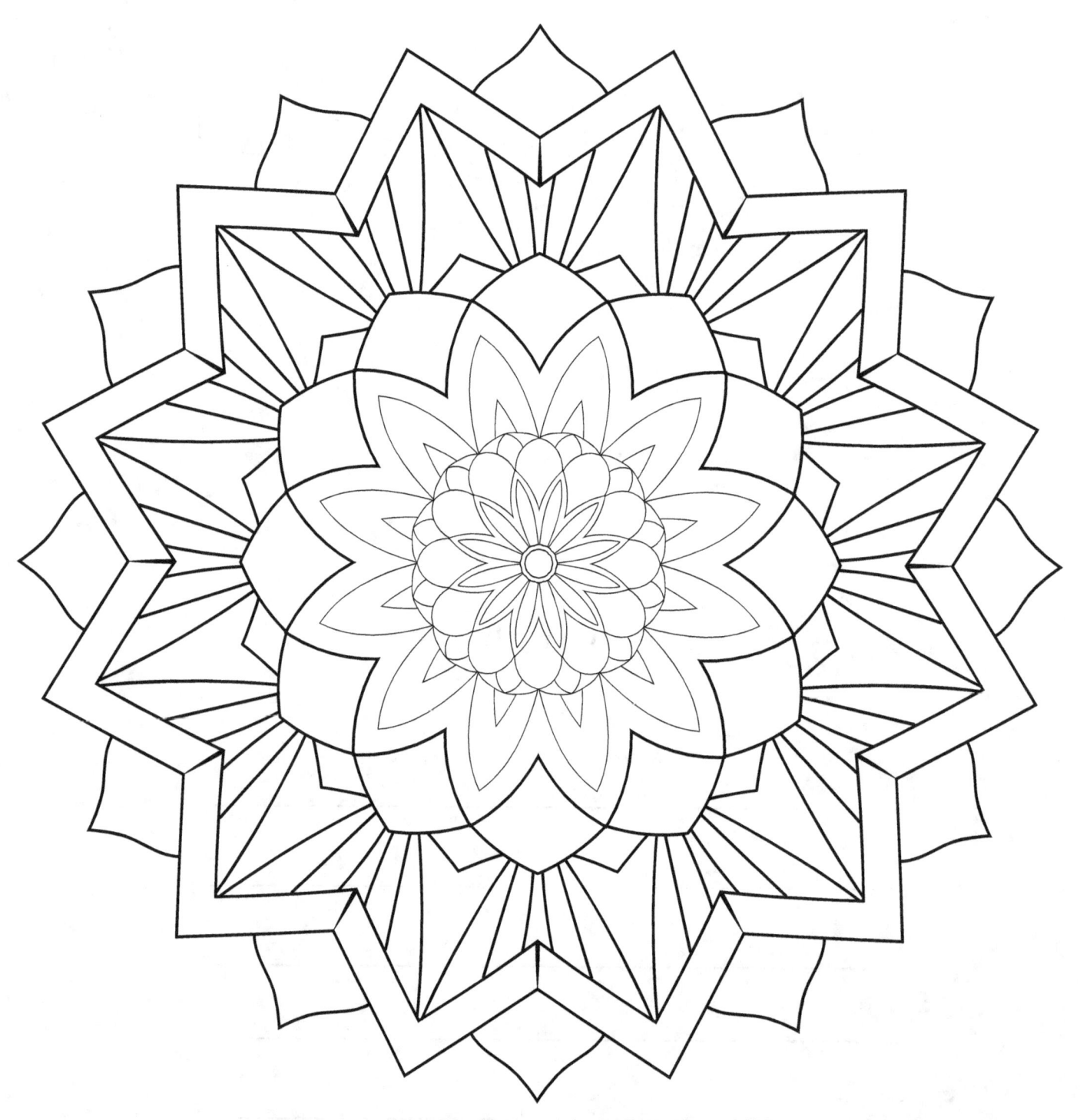

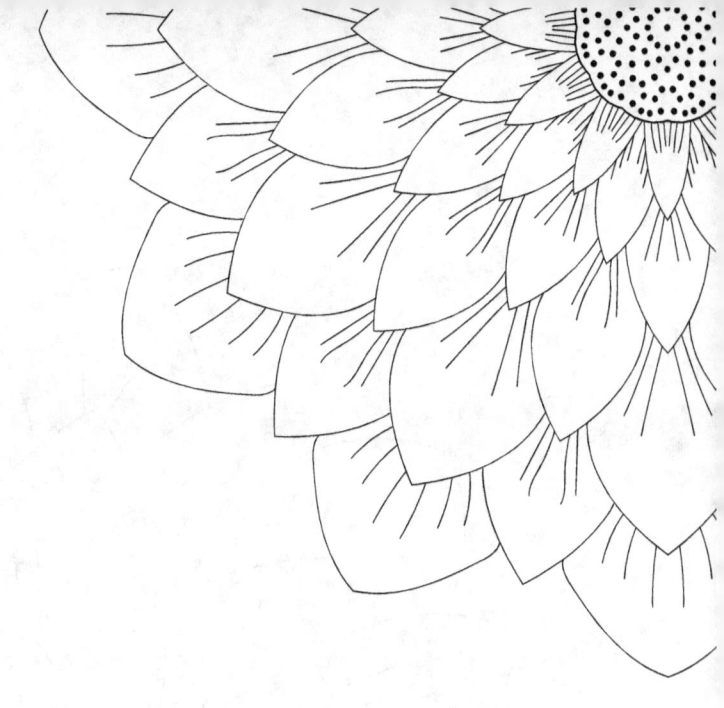

Painted With Love

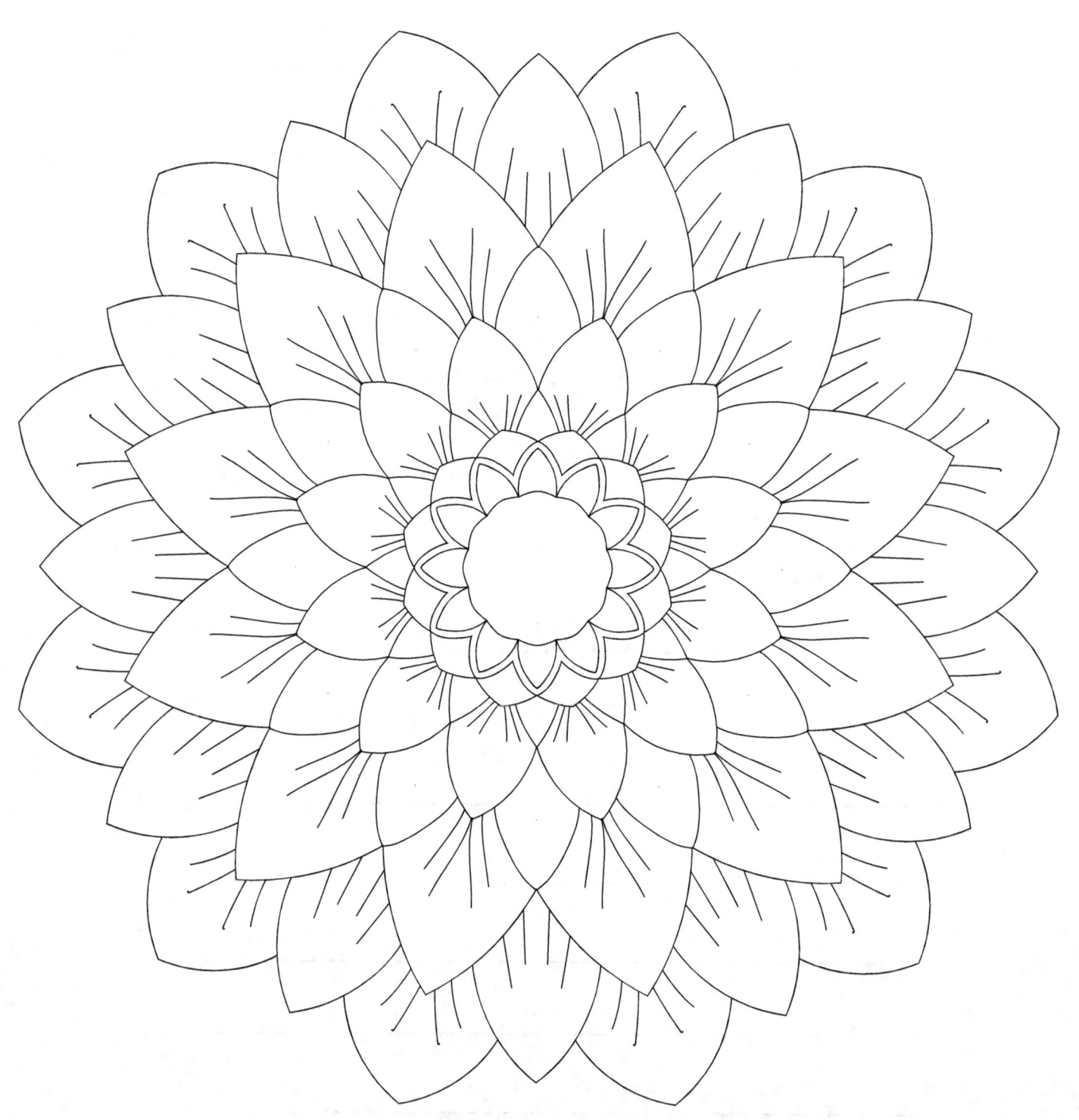

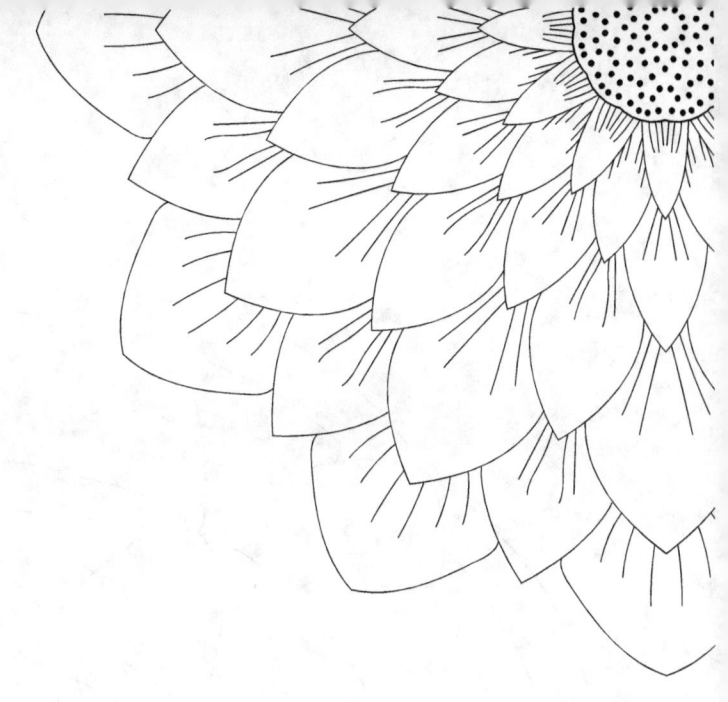

Painted With Love

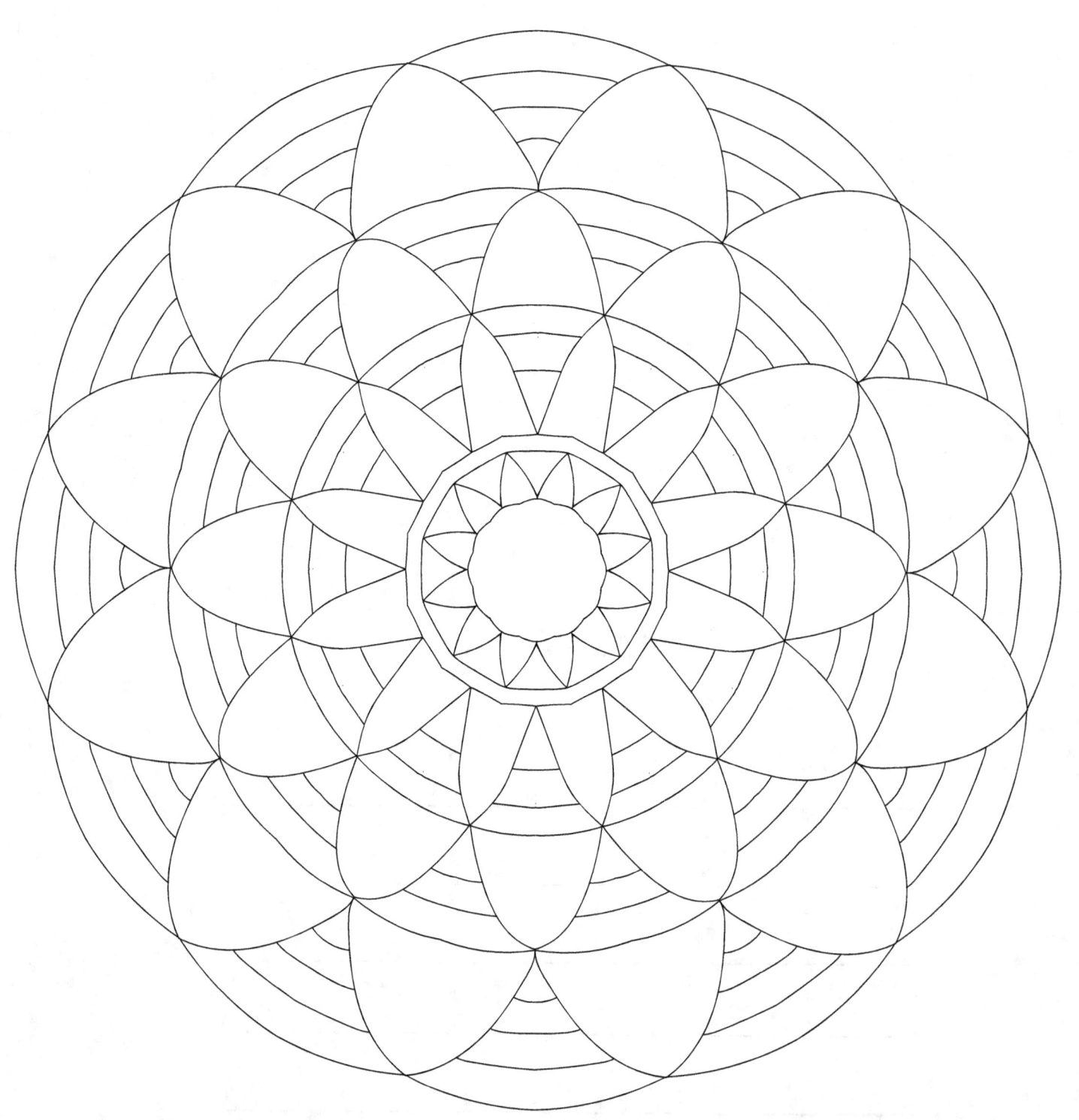

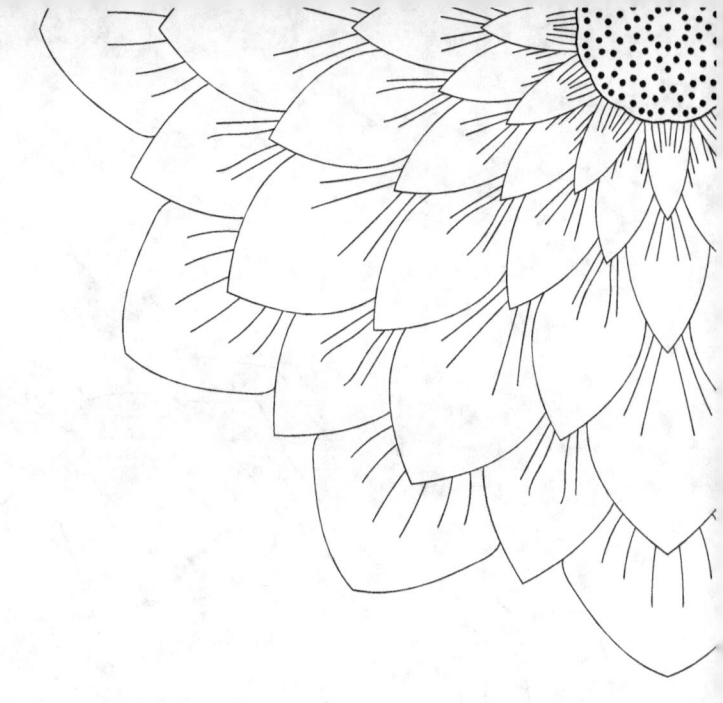

Painted With Love

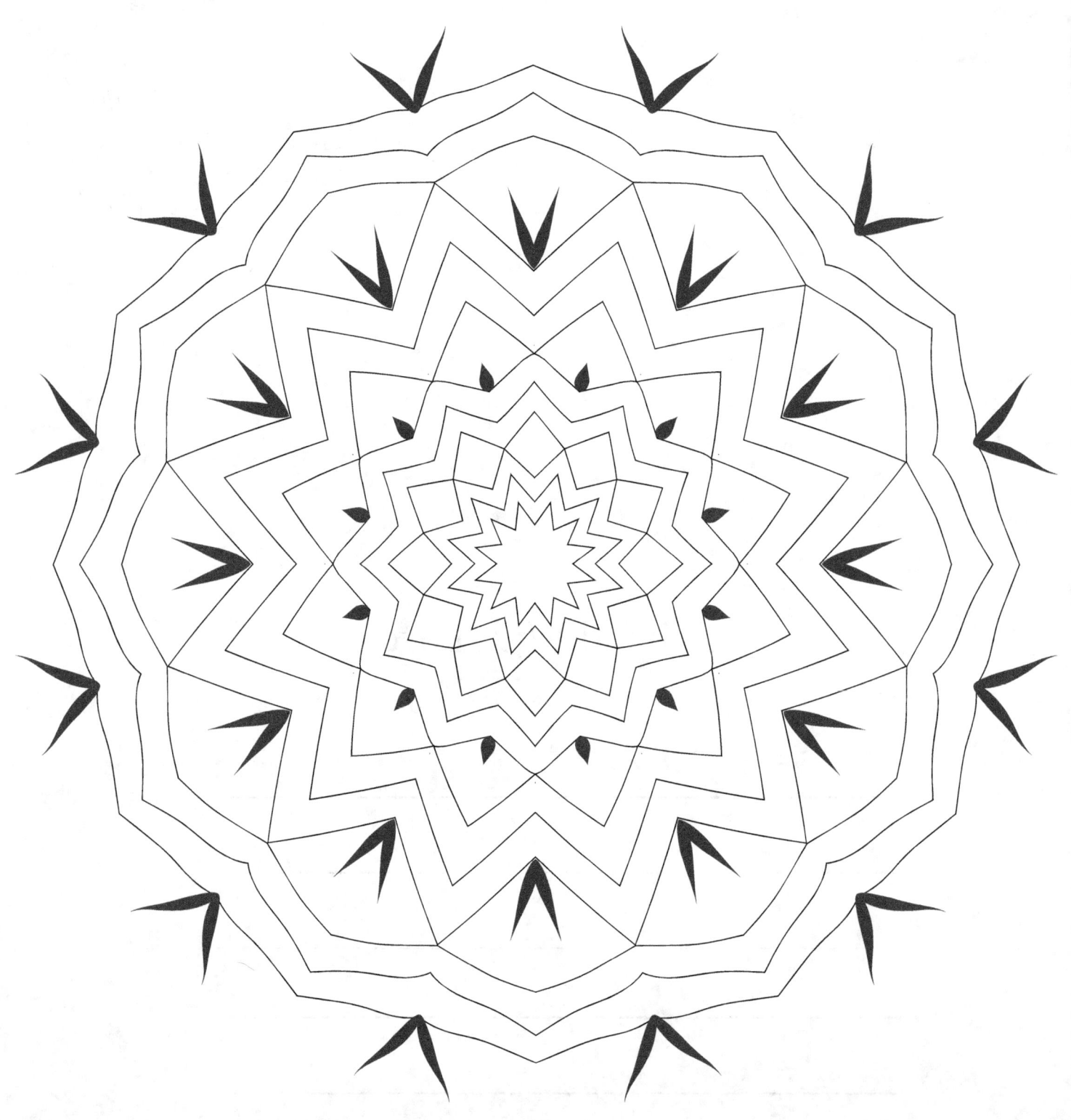

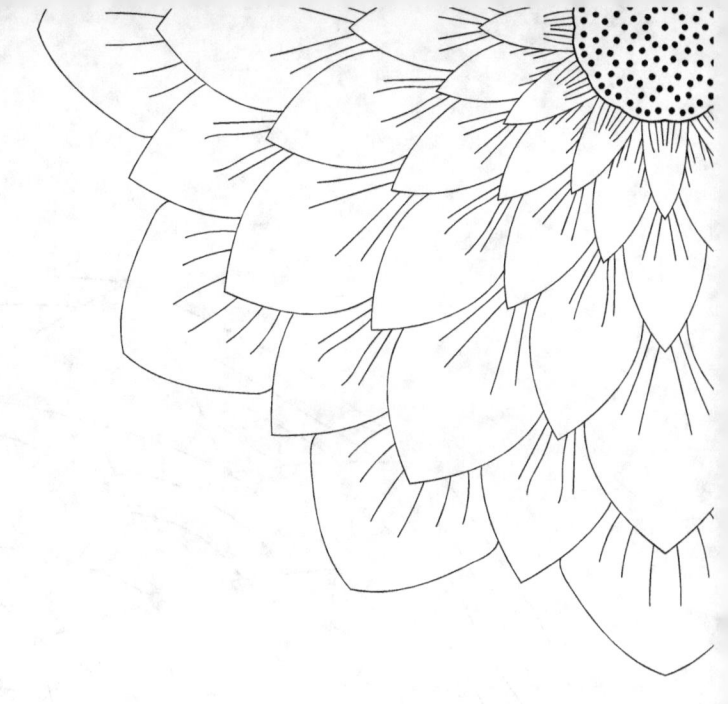

Painted With Love

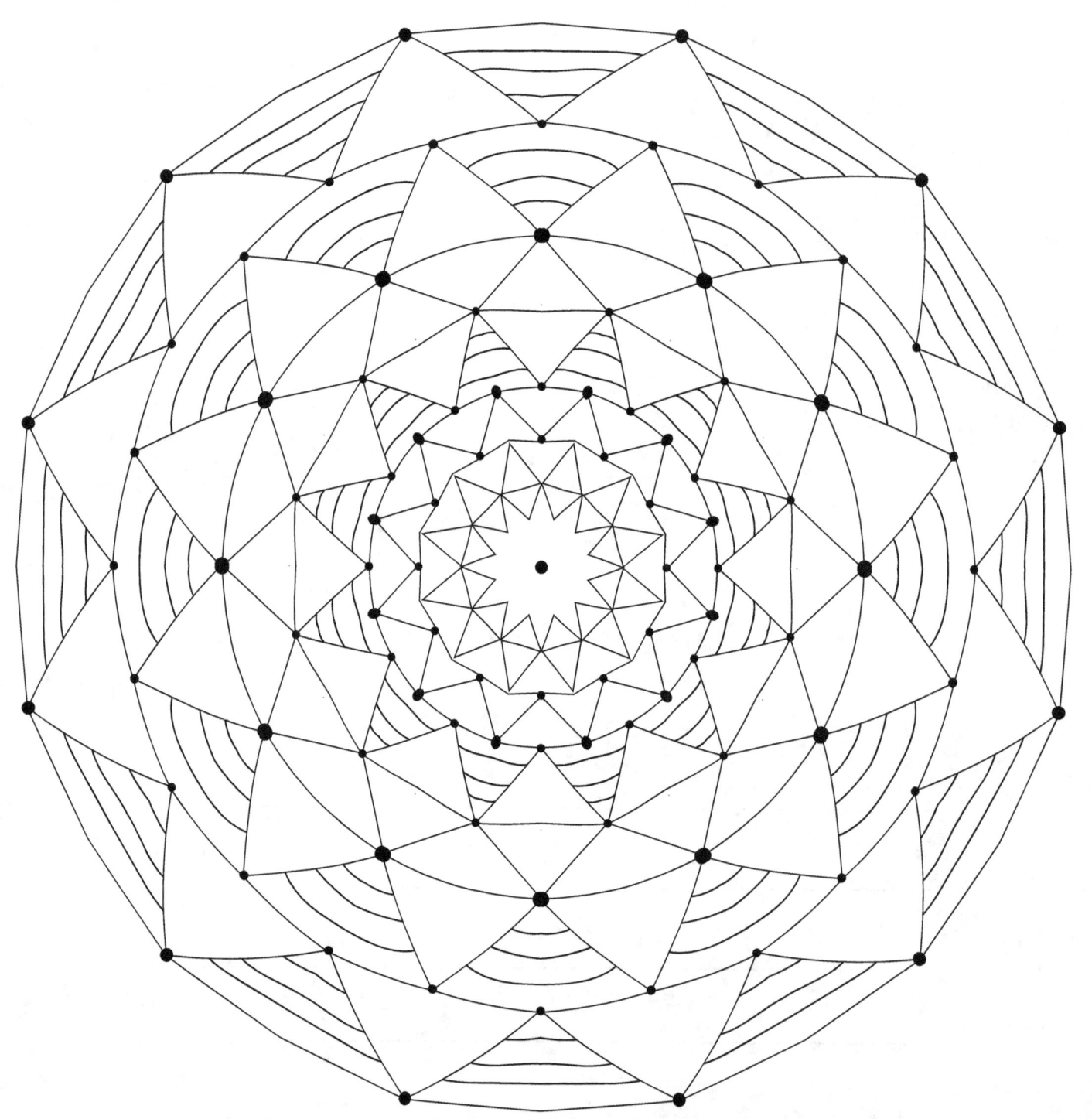

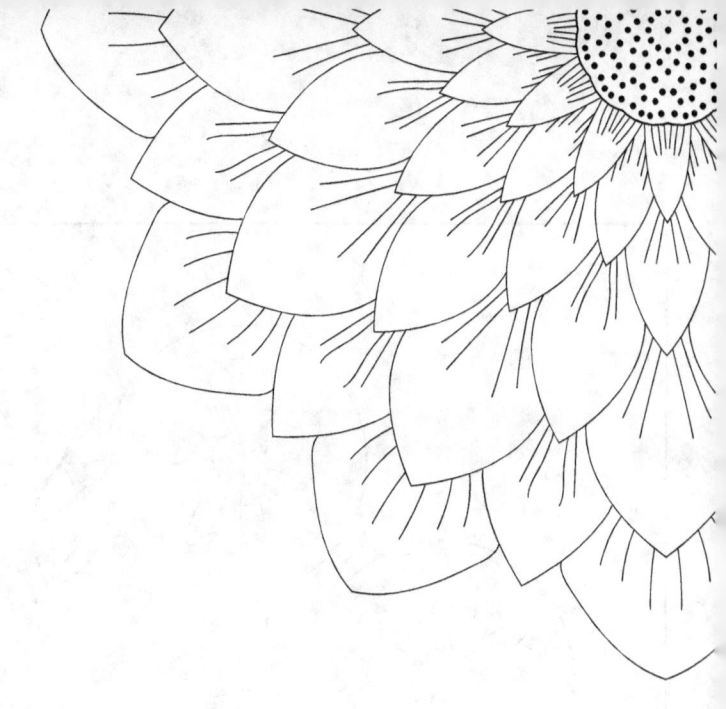

Painted With Love

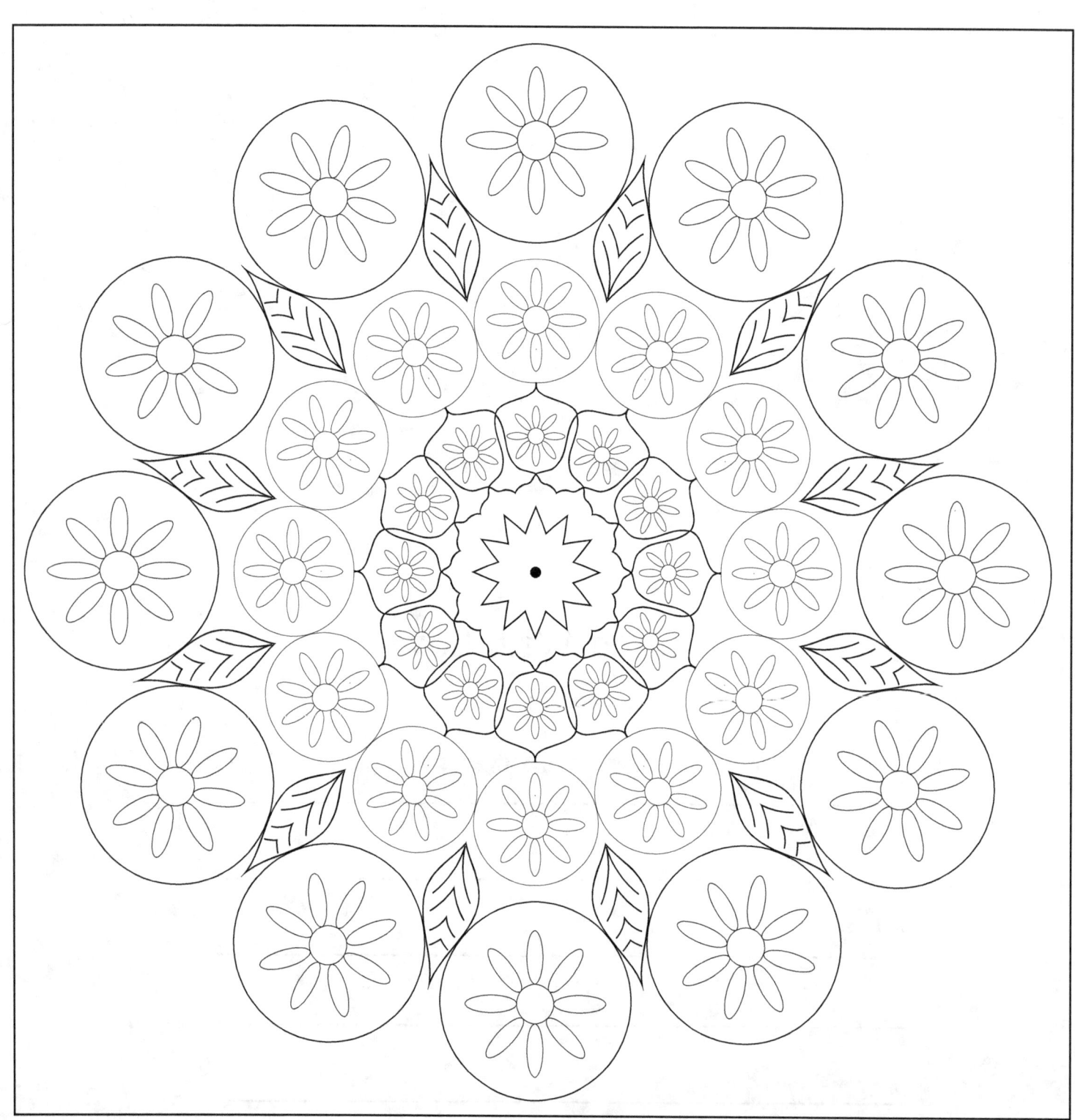

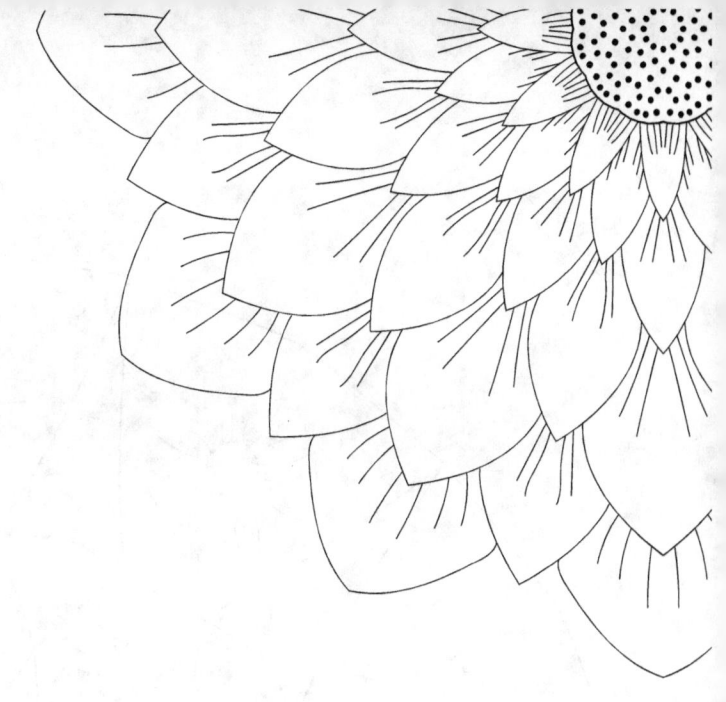

Painted With Love

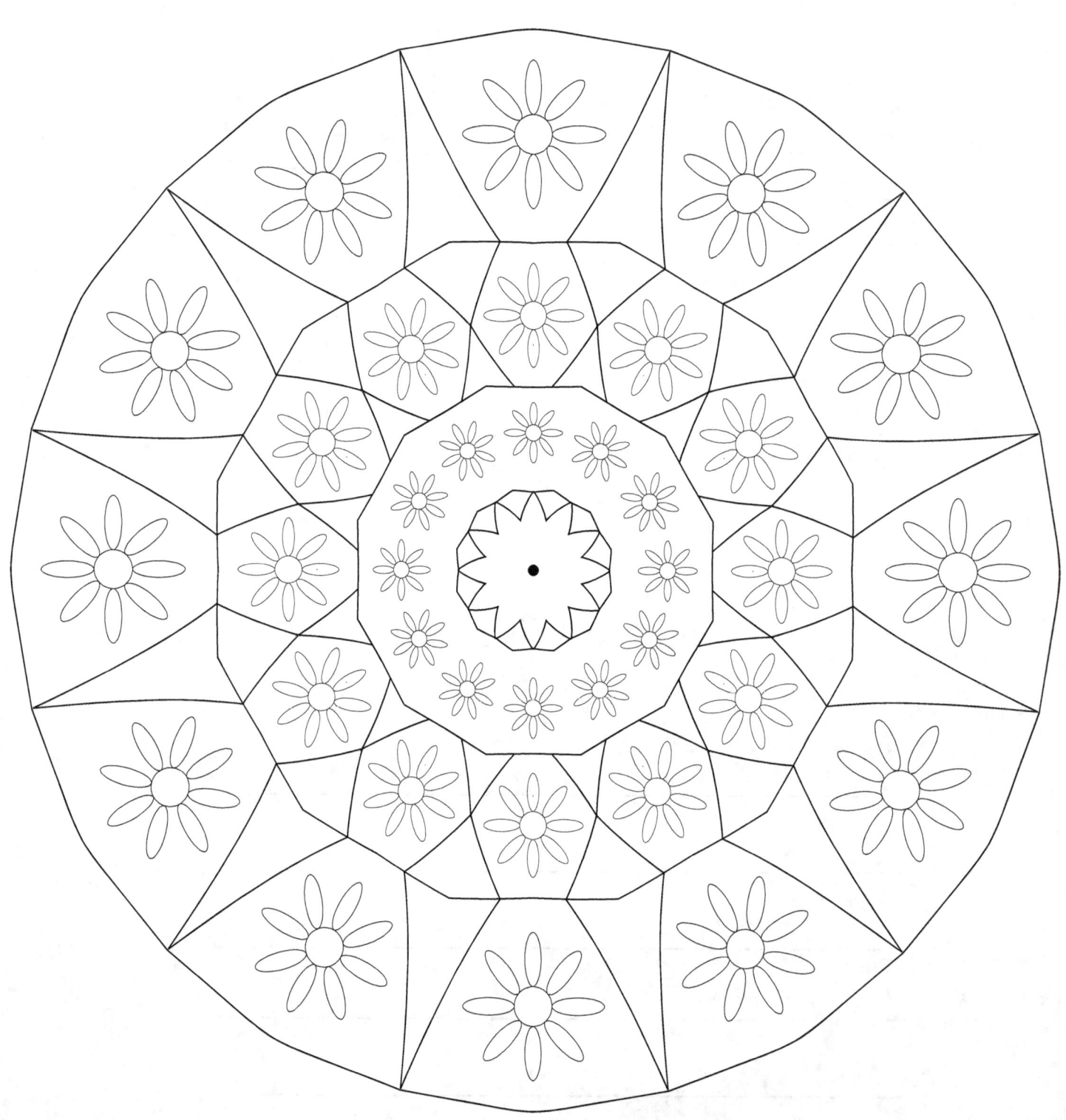

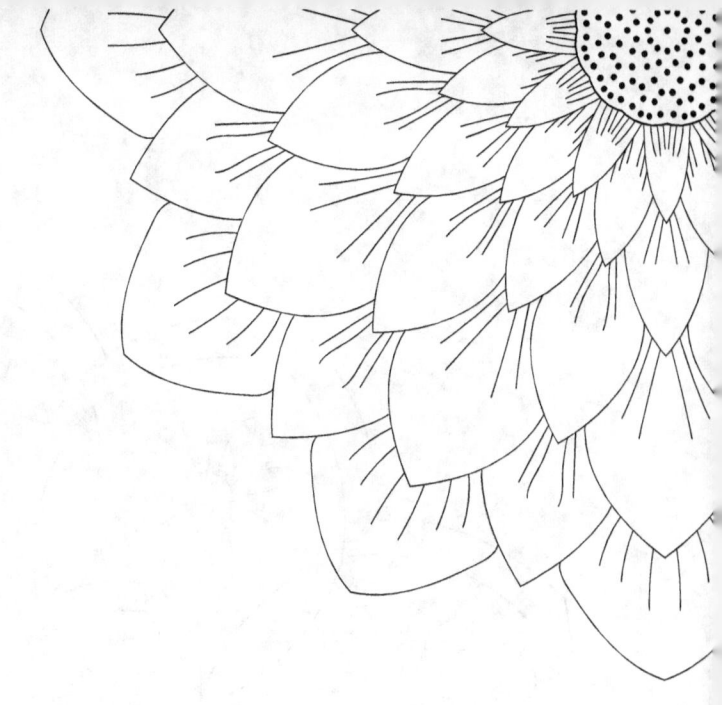

Painted With Love

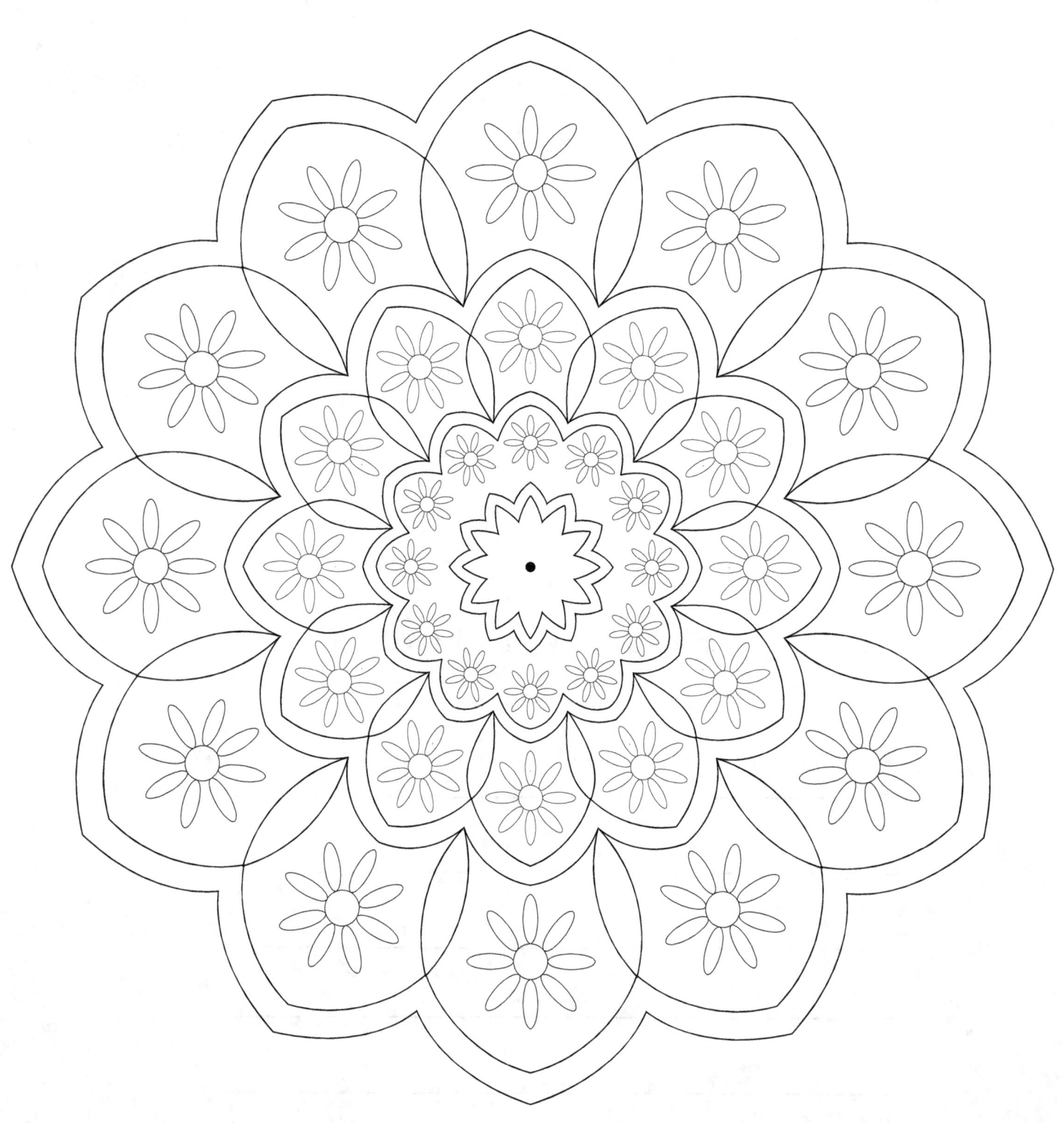

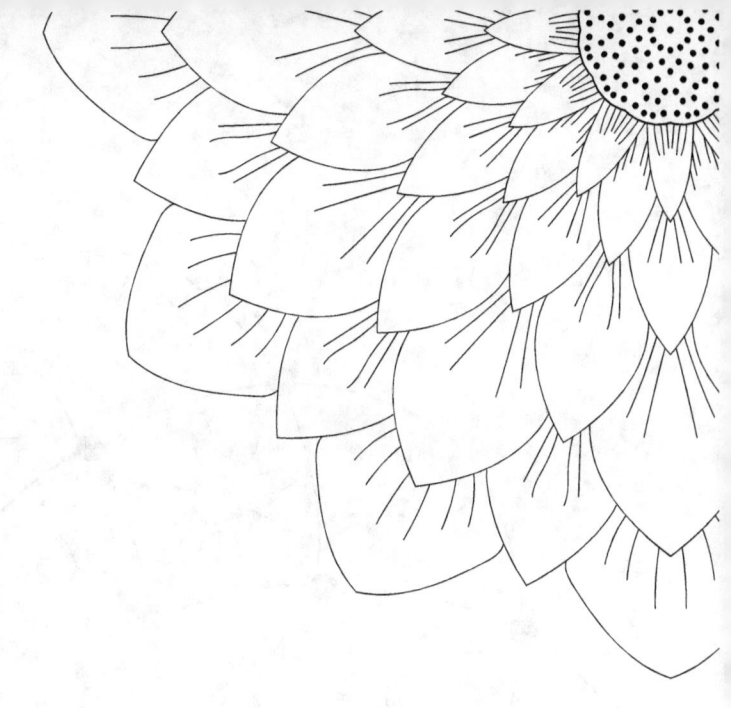

Painted With Love

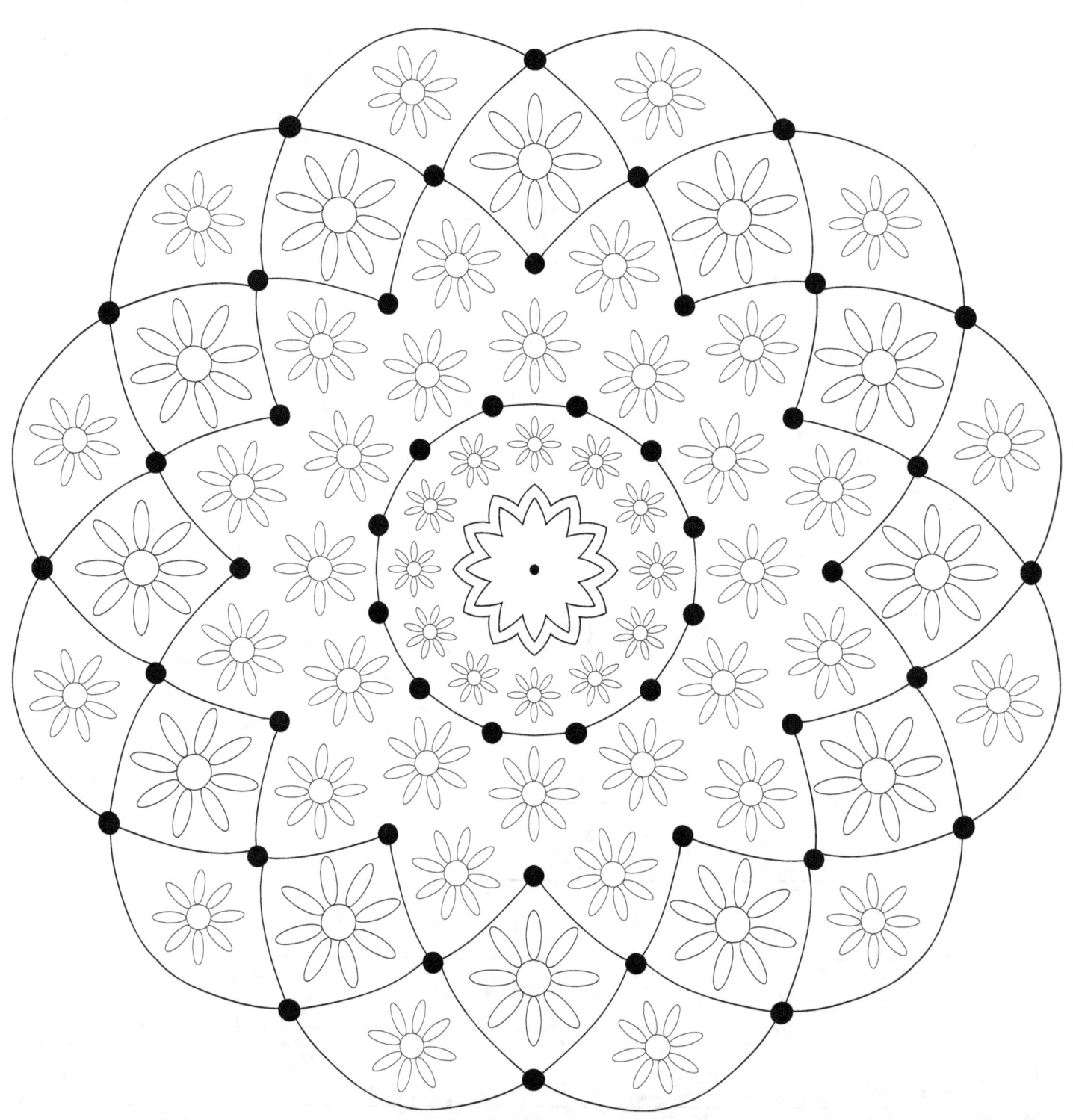

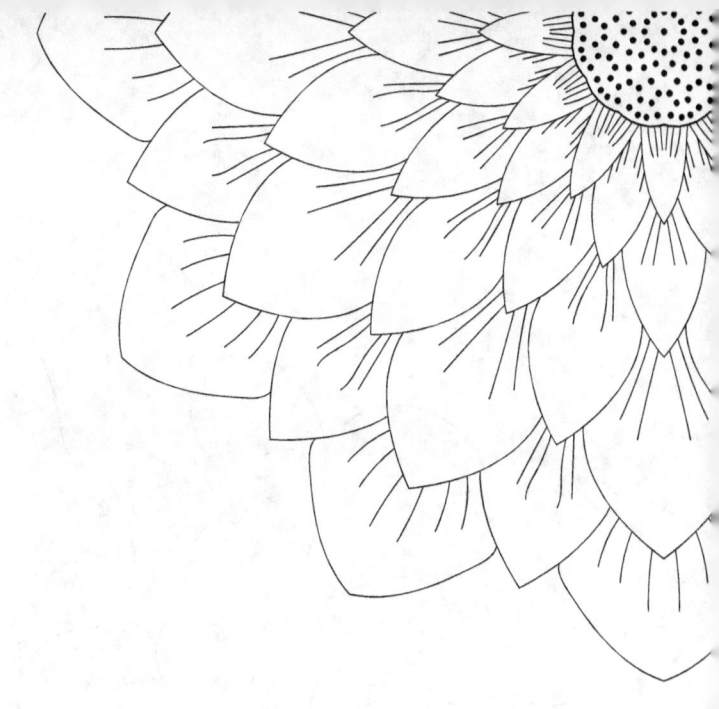

Painted With Love

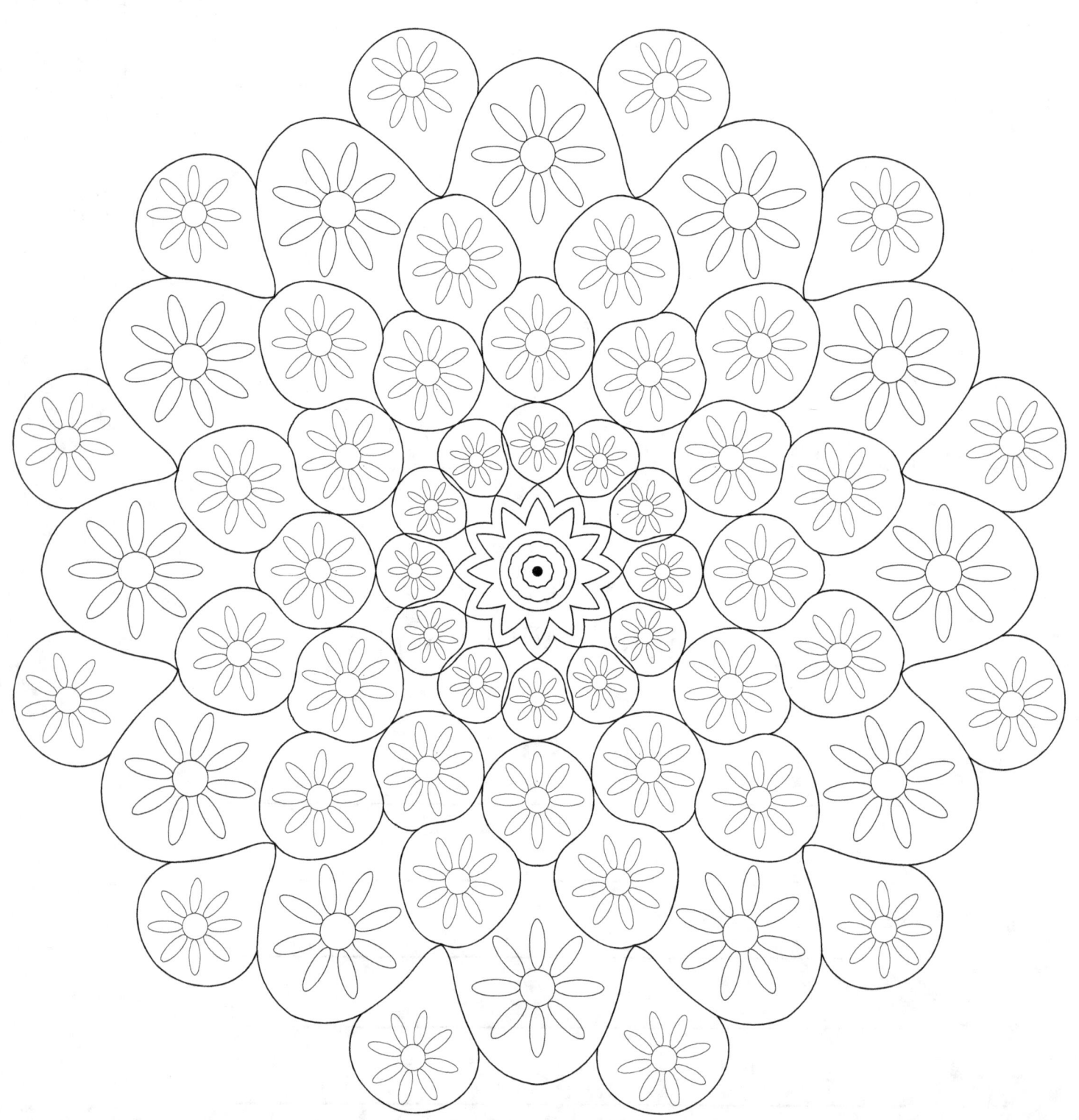

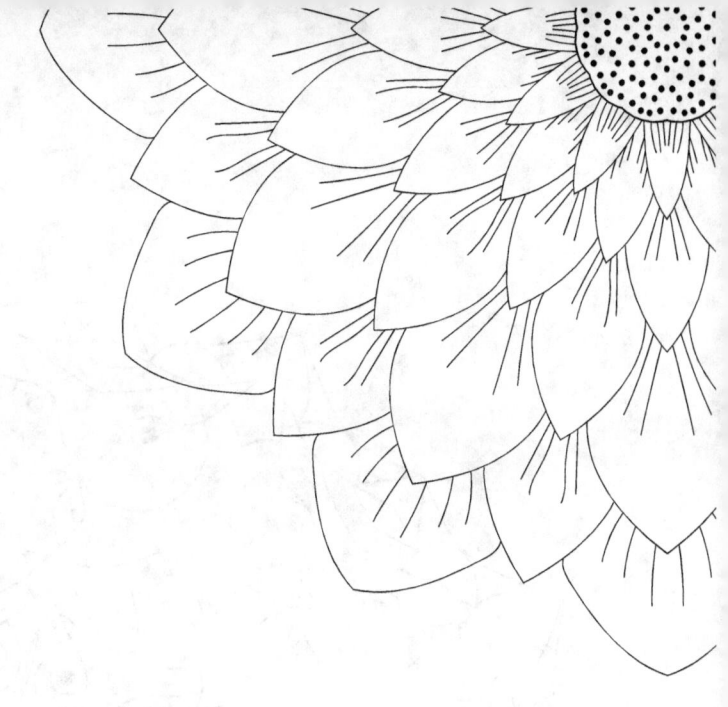

Painted With Love

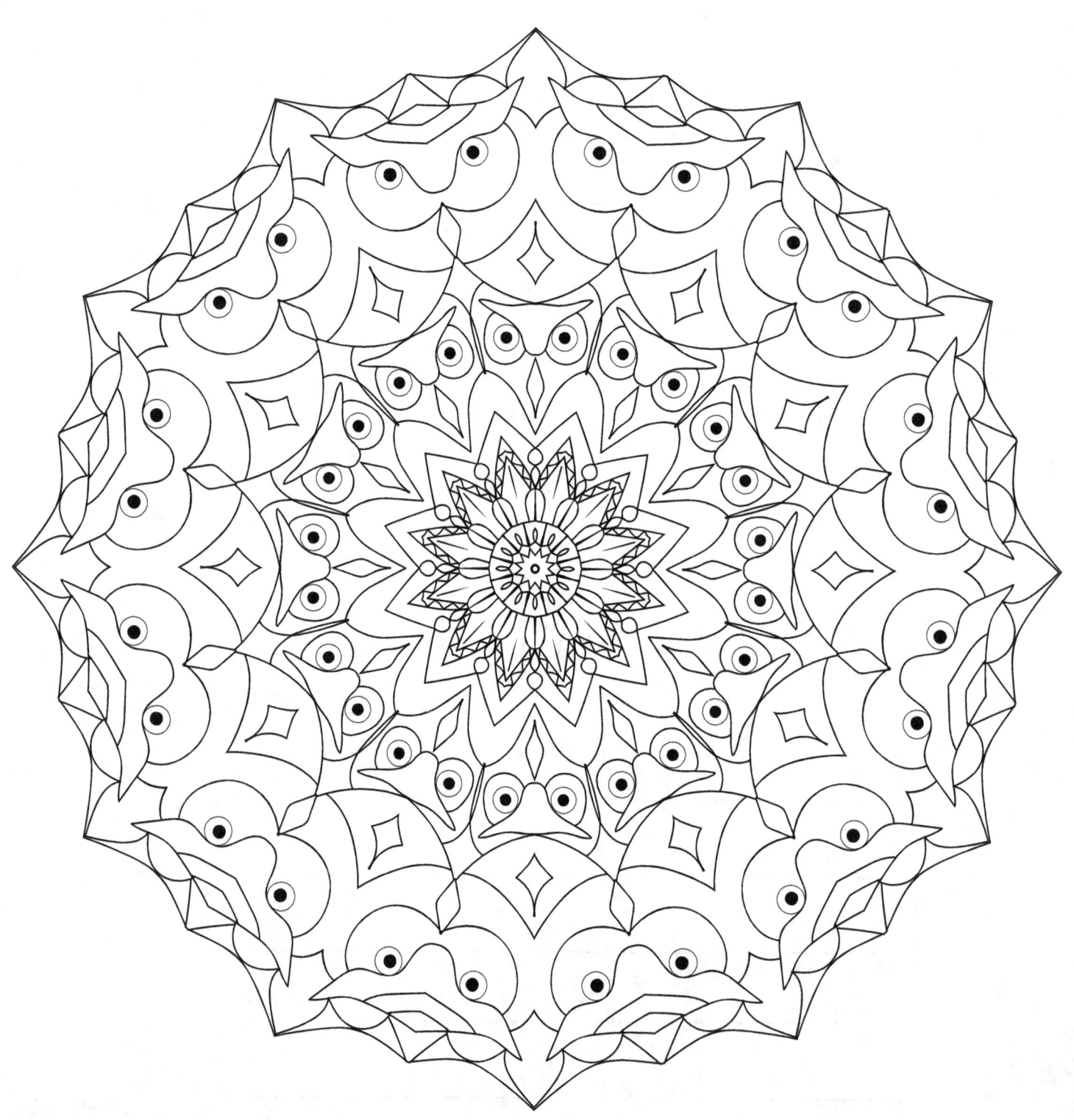

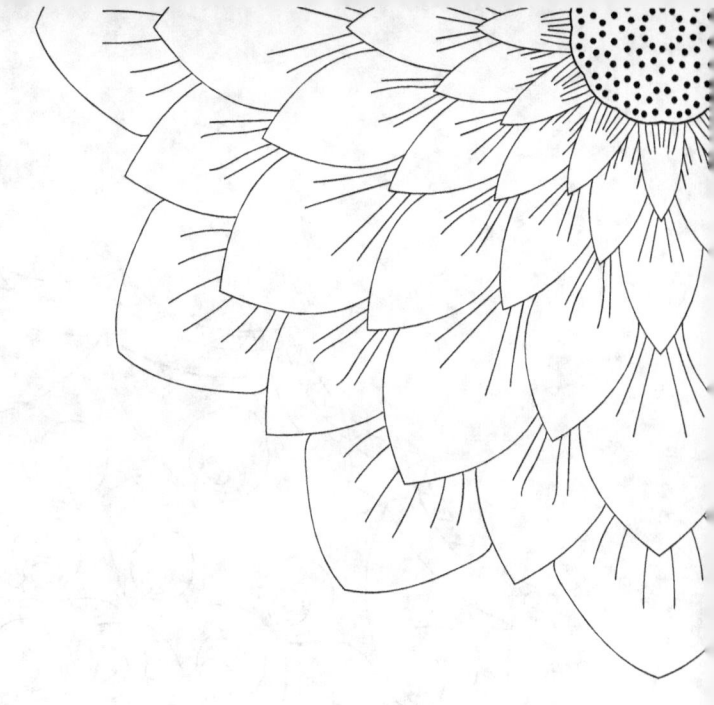

Painted With Love

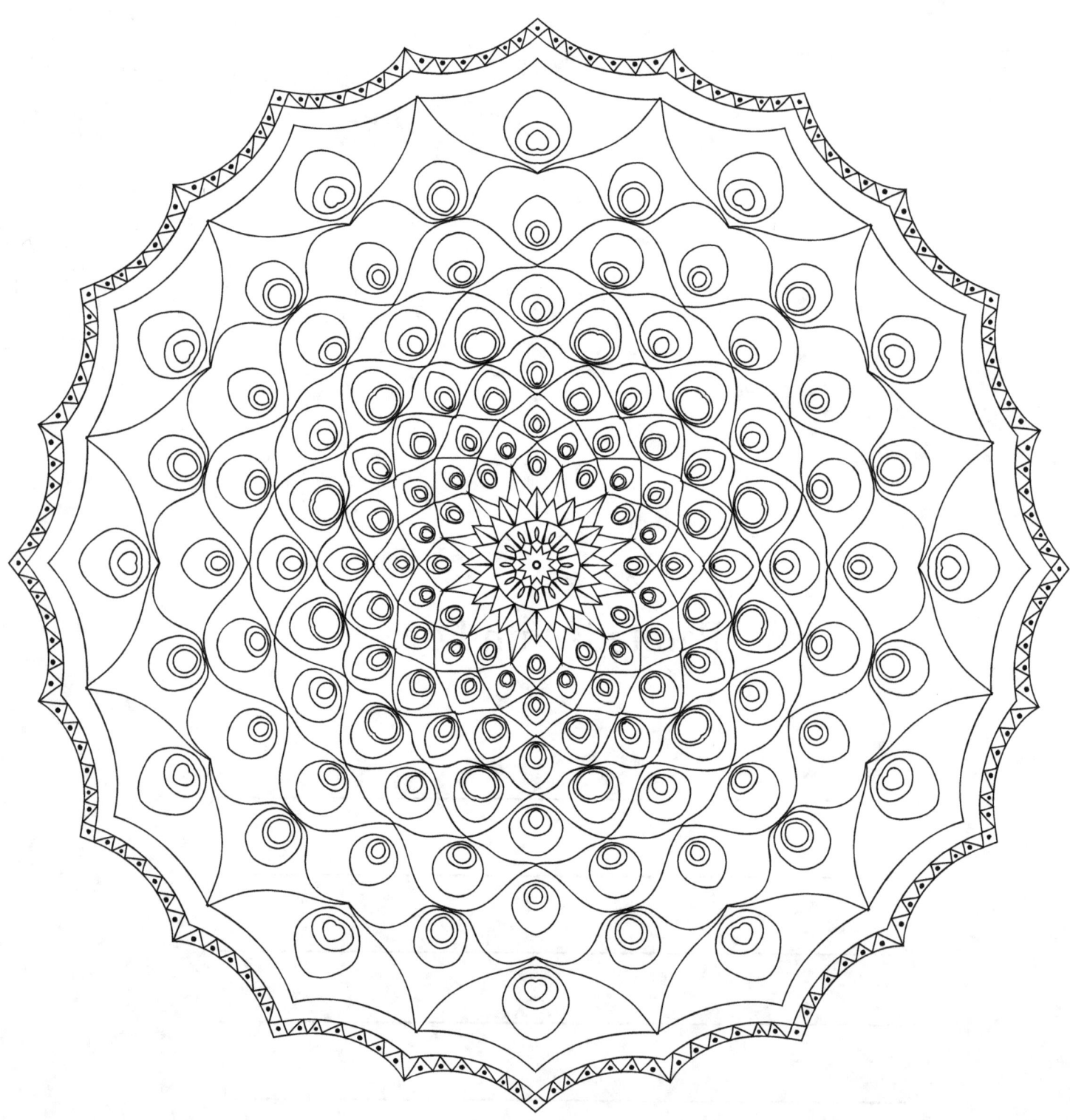

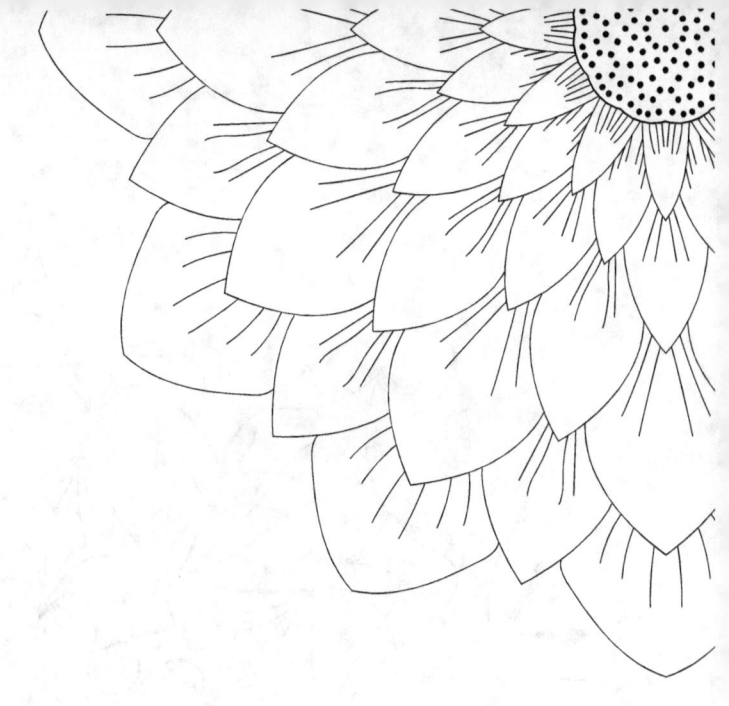

Painted With Love

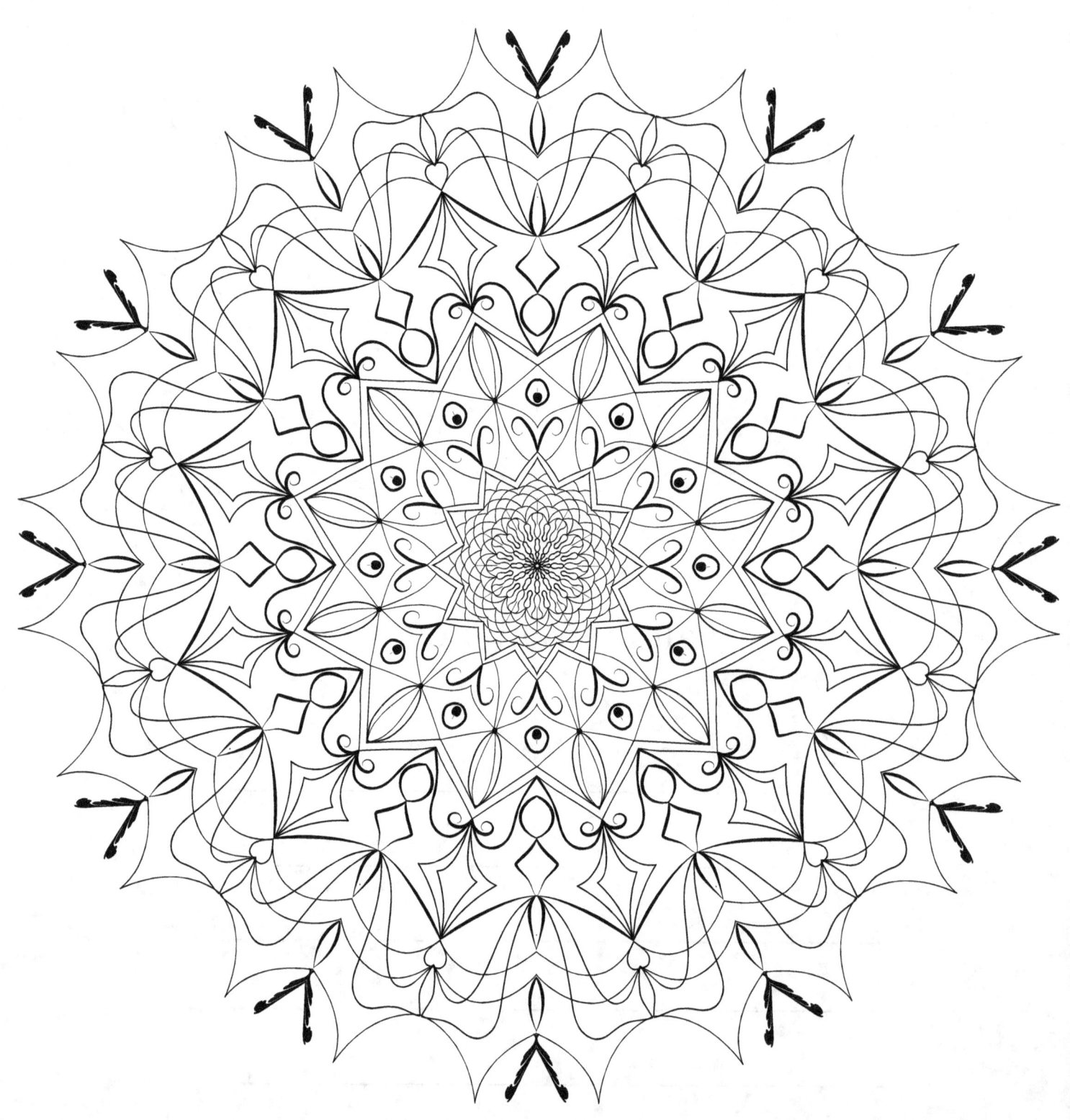

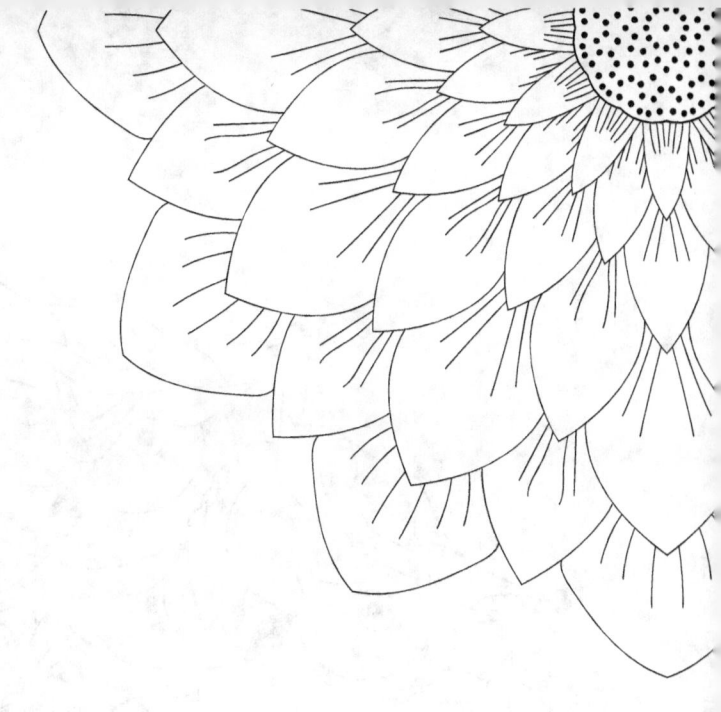

Painted With Love

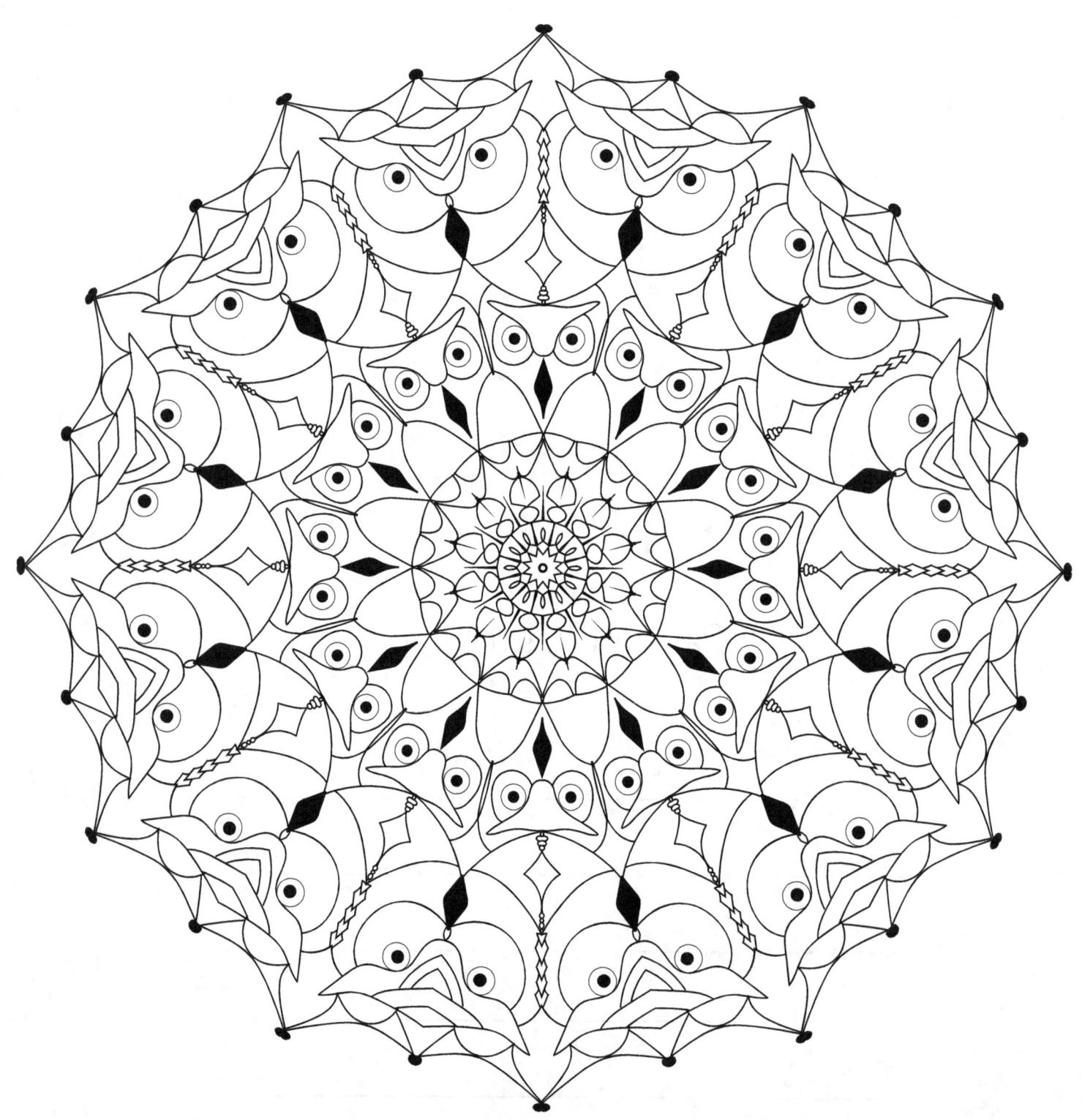

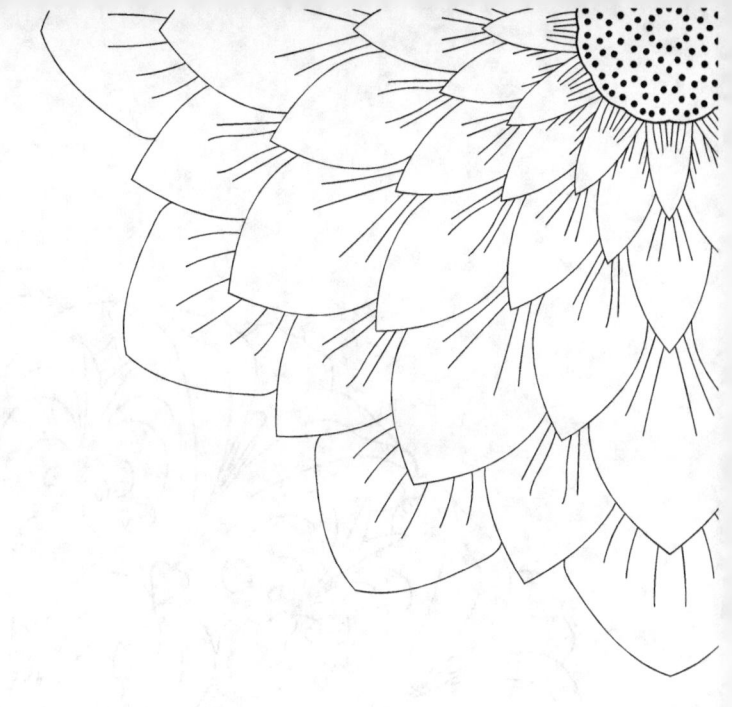

Painted With Love

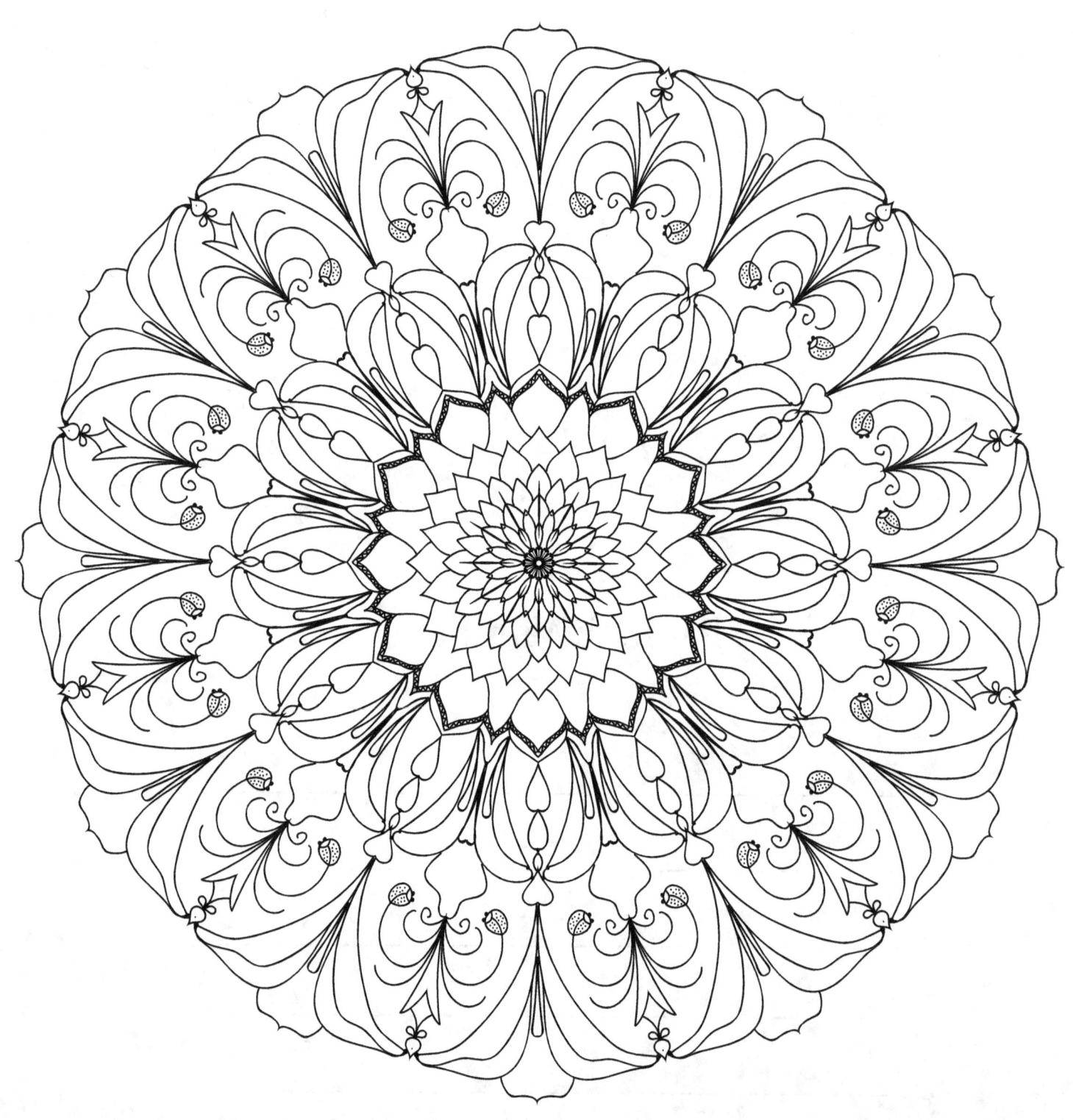

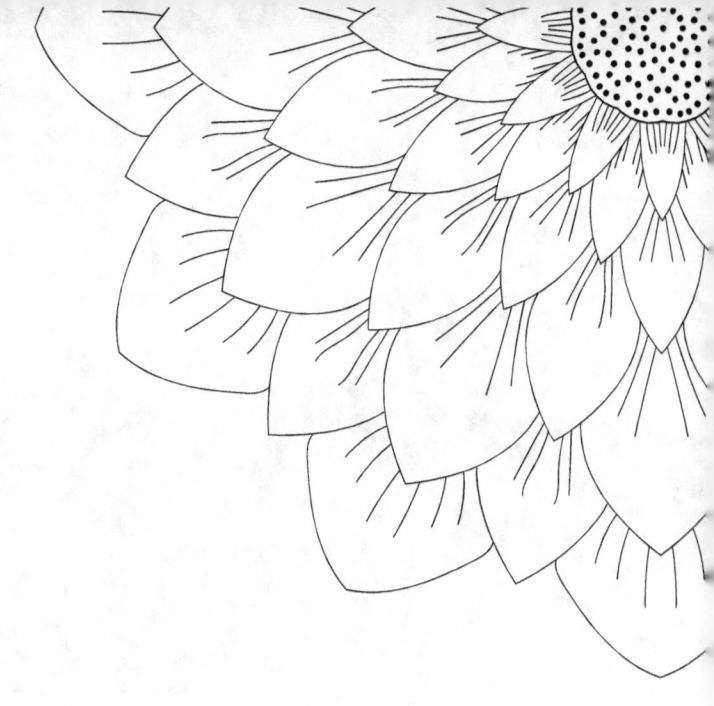

Painted With Love

Thank You!